Painting
with Pastels

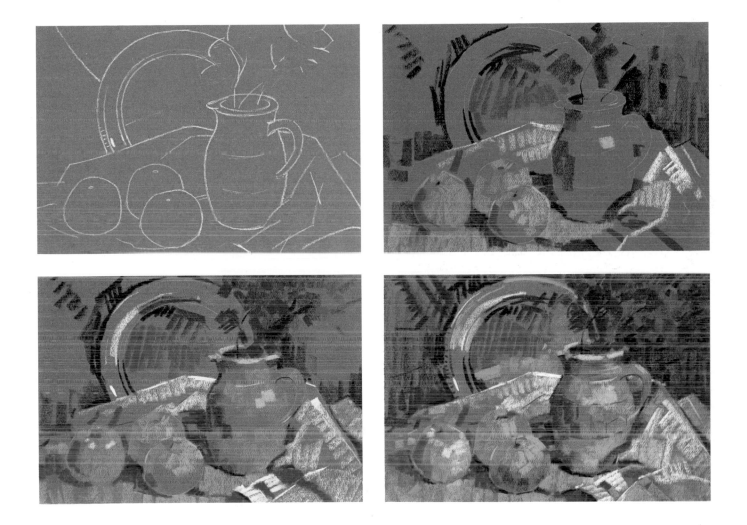

Painting with Pastels

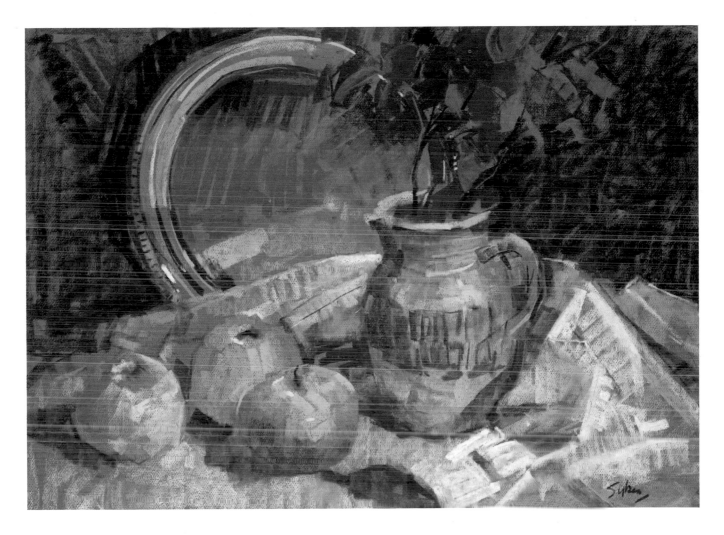

Aubrey Sykes Christopher Stones Aubrey Phillips
Dennis Frost Sally Michel

EDITED BY PETER D. JOHNSON

SEARCH PRESS LIMITED
METHUEN AUSTRALIA

First published in 1984

Search Press Ltd
Wellwood, North Farm Road,
Tunbridge Wells, Kent TN2 3DR

in association with

Pan Books Ltd
Cavaye Place, London SW10 9PG

and with

Methuen Australia Pty Ltd.,
44 Waterloo Road, North Ryde,
NSW 2113, Australia

Based on the following volumes of the Leisure Arts series
first published by Search Press Limited, Tunbridge Wells;
Taplinger Publishing Company Inc., New York; North Light,
Cincinnati; and Methuen Australia Pty Ltd, North Ryde,
New South Wales:

Portraits in Pastel by Dennis Frost

Working with Pastel by Christopher Stones

Still Life in Pastel by Aubrey Sykes

Water and Sky in Pastel by Aubrey Phillips

Landscape in Pastel by Aubrey Phillips

Buildings and Towns in Pastel by Christopher Stones

Animals and Pets in Pastel by Sally Michel

Edited and arranged by Peter D. Johnson
Design by David Stanley

© Search Press Limited 1981, 1983, 1984

ISBN (UK) 0 85532 552 6
ISBN (Aust) 0 454 00705 1

Typeset by Studio 918, Tunbridge Wells, Kent

Made and printed in Spain by A. G. Elkar S.Coop.
Bilbao-12

National Library of Australia Cataloguing-in-
publication data
 Painting with Pastels
 Simultaneously published: London: Search Press.
 Includes index.
 1. Pastel Drawing – Technique. 1. Johnson, Peter.
 II. Frost, Dennis, 1925–1982.
741.2″35

CONTENTS

INTRODUCTION

There are still a few people who dismiss pastels as effete, the medium a dilletante's. The word *pastel* has even drifted into household language as meaning 'soft', 'muted' – 'pale'. This book dispels that notion, nothing indeed could be further from the truth. Pastel encompasses a vast range of artistic expression and possesses characteristics no other medium can emulate. It is an established fact that several old and modern masters worked in pastel to achieve that quality impossible to render in oils, watercolours or acrylics.

While editing and arranging this book I was astonished and delighted at the variety of bold and delicate styles depicted in the illustrations, and the range of subject-matter the artists have contributed to it. Its contents show how versatile the pastel medium is: from the subtle to the dynamic, from the most controlled observation to the most subjective expression.

Almost any surface that will hold a chalkmark is capable of being painted upon in pastel – though all the demonstrations here depicted are on some sort of paper. (Ponder the thought of how many different kinds of paper are available to you – and you will get the inference!) The choice of paper affects the pastel mark; this is but one of the exciting aspects of the medium. Another is that almost invariably the paper a pastellist chooses is coloured and textured (you will not see an illustration in this book worked on a white surface). Paper colour and the 'tooth' or texture of the paper are prerequisites for the pastellist about to embark on a picture – as each contributing artist will explain to you in his or her demonstrations and text – for they affect every mark made upon them by pastel.

Some of the information given in this book by an individual artist may differ – even conflict! – with advice given by others. This controversy is deliberate and healthy, for it not only shows up the individuality and working methods of each but underlines the adage that there is no 'correct' way of painting. It is also to your advantage, for it will enable you to choose from their varied experience the means most suited to your own modus operandi and style when working with pastel. There are no rules in artistic expression other than the discipline of exact control over what you set out to do so that the end-result is personally satisfactory: and only practice, constant practice, brings that goal nearer and nearer. The means justify the end – your finished pastel picture may be on flock or sugar paper, sand-grained paper or tinted Canson; you may employ the broadest sweeping strokes of the pastel stick or dab with the end of it at the surface (or both). It will not matter so long as the end-result justifies what you set out to do.

Almost all pastel techniques are shown in *Painting with Pastel*, and the numerous step-by-step demonstrations show how each artist arrives at his own pictorial destination. You can copy them (copying is one of the best ways of mastering technique), compose your own variants from them, or utilise their illustrated styles as a springboard into the realm of your own picture-making. Use this book as a window to the world of pastel technique. The artists – and I – wish you satisfaction and pleasure in using a medium that has inspired many great artists to produce some of the most marvellous work in the repertory of artistic endeavour.

PETER D. JOHNSON

Editor's note. One important point must always be taken into account when purchasing pastels – unlike colour manufacturers' ranges in oil, watercolour and acrylic there are no agreed standards of colour nomenclature and hue in pastel products. That is why all the artist contributors (with the exception of the late Dennis Frost, who is very specific!) have preferred to indicate in general terms the colours they have used in the demonstrations. Buy cautiously and find out by trial and error (a risk every serious artist takes anyway) – you will soon learn what colours and which manufacturers' products will best suit your requirements.

MATERIALS AND TECHNIQUES

by Aubrey Sykes and Christopher Stones

Materials

Text and demonstration by Aubrey Sykes

A great advantage of pastel as a medium is that delightful results are obtainable from limited resources. Satisfactory results can even be achieved by the use of monochrome only, which means tinted paper and probably three pastels – there is little more economical than that!

What you need is a large drawing board, and a good strong easel. I often use a 'sketching' easel, which leaves both my hands free and enables me to move away from my work. With this I am able to go to my subject, especially if it is something 'seen', instead of transporting the subject to the studio. Be careful always to use a dustsheet under the easel to catch the falling pastel dust; and, when you are working from a sitting position, use an apron. Keep by you a duster to wipe your hands, a wet sponge, a putty rubber, and a jar of rice flour in which to agitate pieces of dirty pastel to restore their original colour. I possess a plastic fisherman's box with many compartments. By keeping the colours segregated – reds, blues, yellows, greens etc., in their particular colour groups – I find they become much less dirty.

You will also require sheets of tinted pastel paper. There are many different kinds: from sugar paper, which is cheap, to the more expensive Canson. Tinting watercolour paper and creating one's own background is a valuable method which I often use, but make sure you allow the paper to dry thoroughly before using the pastel. The most important factor is the 'tooth', or degree of surface roughness. In general, the smoother the ground the less grip you will get for the chalk and the less superimposing of colours is possible, since it is the 'tooth' which holds and retains the pigment. The

Charcoal is essential. It mixes and blends admirably with pastel, and on its own is capable of rendering delightful tonal pictures.

Finally the pastels themselves. Do not be tempted to buy too many at the outset. You must start, of course, with a nucleus – I suggest the 'beginner's' boxes which contain about twelve colours. Then build up your set with small additions, when required, by selecting from the retailer's trays.

Over the years I have accumulated a large stock of colours from various manufacturers, but in general I use soft pastels supplemented by a few harder varieties for accentuating drawings. If a particular colour or tint is not available I use the nearest match and incorporate it into my colour scheme; provided the tone is not upset no one will be any the wiser once the subject has been painted.

To suggest a comprehensive list of colours is virtually impossible, for there are literally hundreds, and the colour scheme for each painting will vary considerably according to subject-matter and the tint of paper used for the support. Many colours may be blended by rubbing, although I prefer the terms 'adjustment' or 'merging', for the simple superimposing of one colour upon another on the art work will blend or change the appearance of most tints without the need to rub. Tints of a particular colour are known by a number. Find the precise tint you require and make a note of the colour and tint number for reordering.

Keep your requirements simple. Do not be tempted into purchasing unnecessary equipment.

See also 'Organisation and care of materials', page 127.

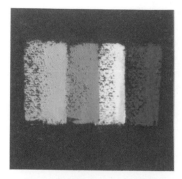
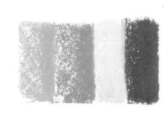
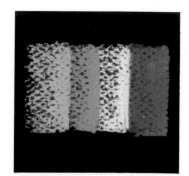

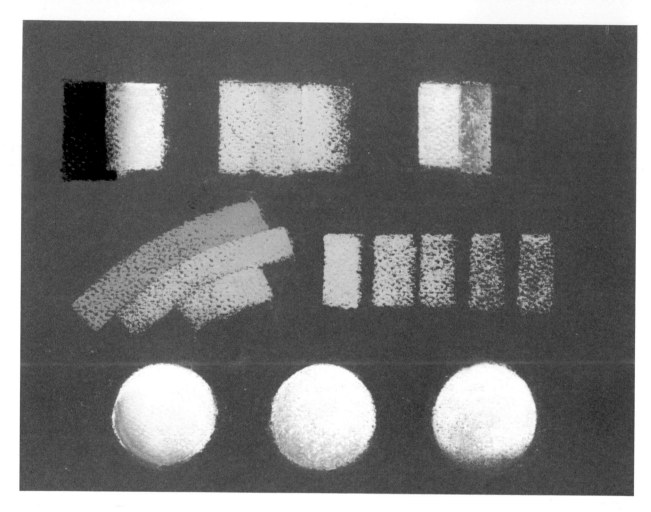

Colour

Begin your experiments by using pastels on white paper, for this shows the unadulterated colours and their mixes. Then try the same pastels on a variety of coloured papers, using similar pressures, and notice how different the effects are.

The examples above are obtained by using a portion of pastel on its side. (This is, incidentally, the quickest method of covering the ground; also it provides a sharp edge which is useful for drawing lines and accents.) Continue to experiment by gently rubbing the edge of the solid colour sample into the paper with your thumb or little finger; much can be learned by doodling on various grounds. Place another opaque colour on the paper, together with one equally strong alongside and gently merge the two edges together. Using black and colours in the dark strength, try intensifying the tones, bearing in mind that manufacturers only add black to darken and white to lighten their pastel tints.

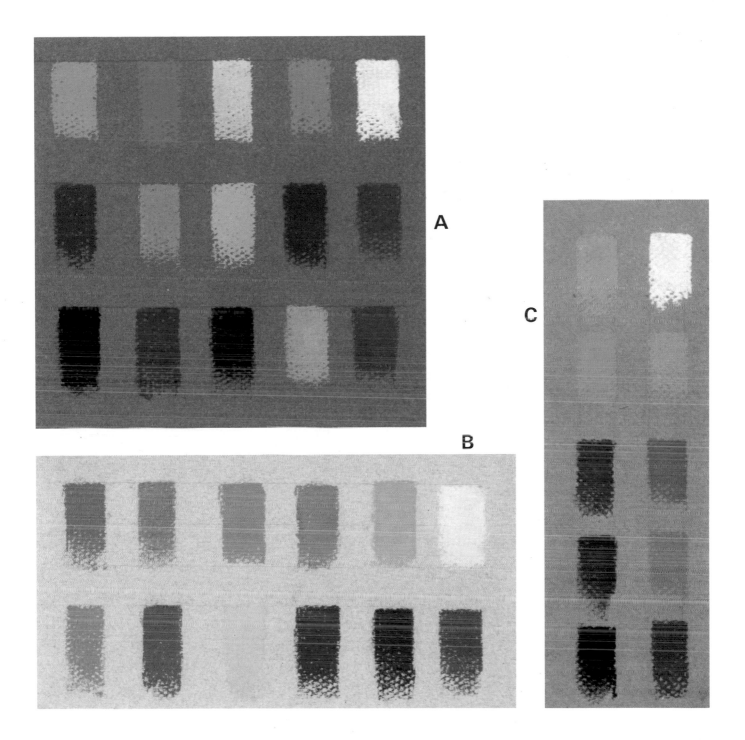

On this page I show the swatches of colours used in three of the demonstrations in this book, so that you can compare the identical colours when applied to a variety of tinted grounds. As there is an amazing *apparent* change, it is wise to have a test strip of similarly tinted paper to the one on which you are working, in order to find the requisite pastel colour for the job. Because of this change one cannot recommend a specific range of colours without knowing the particular group being painted and on what ground. You must, however, have reds and browns for warm colours, blues and purples for cool effects, and yellows and whites for a bright range. Black and grey are essential for the darks and for general tone but, again, all are affected by the ground: the ground colour penetrates the pastel because of lightness of application, creating a change; at other times it is proximity which causes two colours to affect each other.

The swatches here are of colours used in the following demonstrations: 'A' – JUG OF FRUIT (pages 59–61); 'B' – INTERIOR (pages 74–5); 'C' – BOTTLES (pages 53–5). Compare the apparent changes caused by the ground papers. It is instructive.

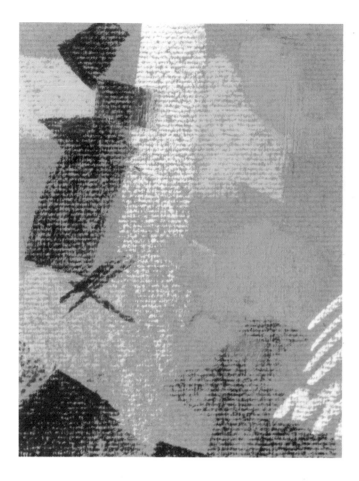

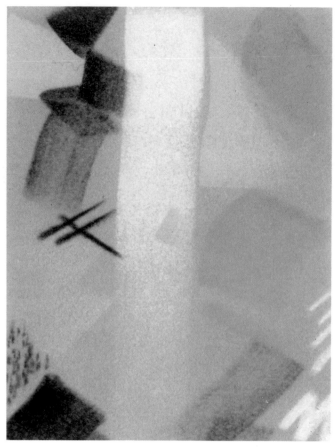

Ingres (Fabriano) paper

This is one of the most widely used papers for the traditional approach to pastel. Normally the picture is built up with light pressure strokes, allowing the grain of the paper to show through. Great care is taken to choose an appropriate colour of paper for the subject. For best results very little overlaying and intermixing of colours is done and hardly any touching in with the finger. Because you cannot blend colours together so readily you need many more different tones of each colour in your box.

Velour paper

This has a furry surface, and is widely used in Europe. When painted, it gives a sensuous soft image, but is not capable of providing great clarity. It is better not to mix colours on it, so you need a large number of pastels, but as they wear down so slowly on this paper they last much longer. Velour paper is made in a range of colours, and is usually allowed to show through in places in the finished painting.

Marks and papers

Text and demonstrations by Christopher Stones

When you start to use pastel it is worth experimenting on sugar paper or any cheap rough support to see the kind of marks you can make: the light granular stroke with the side of the pastel; the varied pressure of stroke; rubbing an area in completely and putting a light granular and unrubbed stroke of contrasting tone over it; seeing how misty an image you can get one moment, and how clear and sharp at another. On these two pages I show four of the most widely used types of paper that pastellists choose.

Pastel is basically a very fine cosmetic chalk mixed with pigment, and so it follows that the palest colours will feel the softest, having a large quantity of chalk, while the darkest colours are mostly pigment and can feel rather gritty, depending on the pigment used, so there is some variation in a single brand range. The choice of the medium – soft or very soft – is essentially a personal one, and depends on the paper used and the type of work you are doing. There is no point in trying to press very hard to make a clear staccato shape if you have a very soft pastel – it will just disintegrate! I use all consistencies of pastel and add to my range some small conté sticks which are square in section. I also occasionally use pastel pencils.

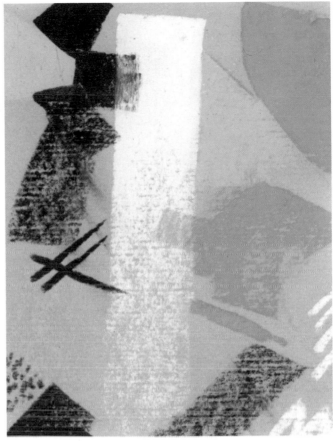

Watercolour paper

Watercolour paper is normally primed with an acrylic wash, which both tints it to the desired colour and toughens the surface. This surface is Bockingford NOT. The primed colour shows through the light strokes of pastel as in the first example, and again there is no finger work in the traditional approach to pastel. It is excellent for impression or sketch approach to painting with pastels. The rougher the paper the more difficult it is to fill the surface with pastel to achieve a fully worked block of colour.

Sand-grain paper

This is my own personal preference. The quality I like best – glass paper – is normally used by woodworkers for finishing and smoothing wood surfaces. The 'tooth' holds each mark I make ideally, and allows perfect clarity of image as well as the subtlety of edge available to the oil painter; and because colours can be blended on the paper all the soft gradations of a watercolour wash are possible. You need a smaller range of colours, but you use them up faster. Mind your fingers!

Fixatives

Fixatives are used to bind a pastel painting onto its supporting surface but experience shows that they ultimately impair permanence. When fixed, some pigments lighten and others darken; some become warmer and others colder in hue, and this can upset the interaction between colours. Fixatives do to some extent impair the surface glow or bloom of a pastel painting, making it flatter. However, there are times during the course of painting when it is useful to set part of the underpainting and apply unfixed strokes on top.

Charcoal, being so much lighter in weight and easily blown or knocked off, *does* need to be fixed, especially if used as a drawing aid before applying pastel, for it can taint the lighter colours applied over it.

In the mid-eighteenth century several painters experimented with fixatives. Their fixed paintings have survived reasonably well but the unfixed ones remain as if they were painted yesterday.

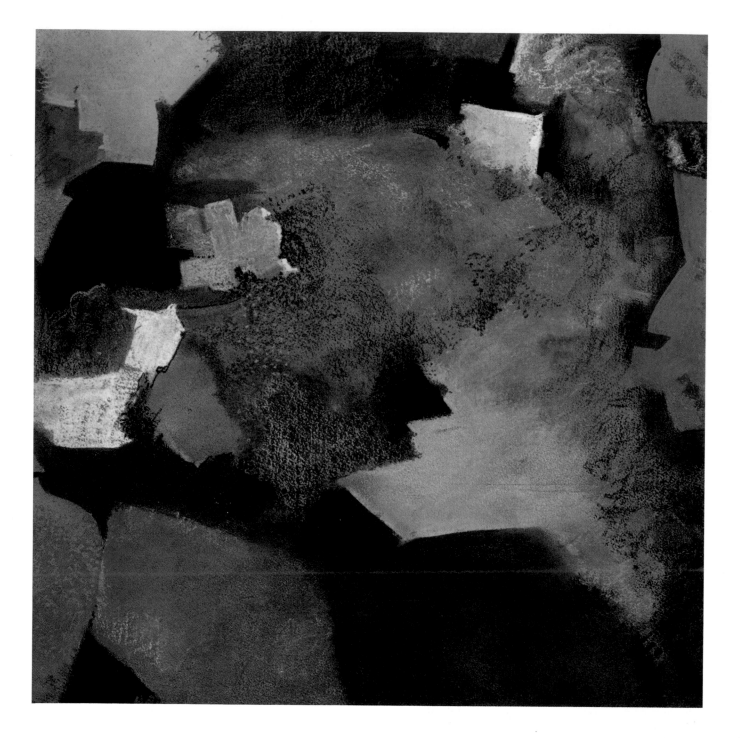

The techniques demonstrated: Non-figurative composition:

Whether or not you wish to work in abstract shape it is important that you employ a wide variety of textures and character of edge. In the composition on this page I used a piece of Bockingford NOT surface watercolour paper. I primed it with a mixture of ultramarine, burnt sienna and raw sienna acrylic paint, which I applied to the sloping piece of paper in the manner of a watercolour wash. The mixture produced a speckled pattern of deposit which settled in the indentations of the slightly rough paper, and was allowed to dry.

Details from this picture are shown opposite.

Detail 1

Detail 2

Detail 3

Detail 1

In this central portion I have completely obliterated the tint of the primer coat. The light blue area is rubbed in fully with the fingers and then, with a clean finger lightly travelling over the surface, the deposit of colour is partially wiped off the raised pattern of the paper, while the indentations remain filled. The dark cool grey has just the fully rubbed-in coat, but by pressing hard on the pastel stick a sharp edge is made. This area is varied by smudging or by the addition of the dividing line. The top left area is covered with a rubbed-in warm grey and the edge left flaky. I set it with fixative and then with a light pressure application of pale warm grey I bring back the pattern of the paper.

Detail 2

Apart from the filled black and yellow areas, the primer coat is visible through most of this top right portion of the painting, but it is covered with light-pressure strokes in varying colours, sometimes with the flat of the pastel and sometimes with the end. Again the character of edge is varied.

Detail 3

The lower left detail shows variety of texture: smooth light-pressure strokes over a smoothed ground, and pointillist – that is dabbing the stick end onto the surface to achieve an irregular dot – also on a smoothed ground. I also used a variety of edge marks.

LANDSCAPE

by Aubrey Phillips

I am often asked why I find pastel such an attractive medium for painting landscapes. Its appeal to me lies primarily in its immediacy: after observing my subject and the particular colour I want to put down, I can select the appropriate pastel stick and apply it to the paper without thought of mixing or diluting a pigment. I also like the feel of the pastel stick between my fingers and the direct contact with the paper – there is no brush or palette knife between me and the mark I make. The mark itself is also far more directly transmitted by my hand and fingers – I can press the stick firmly to the paper to make a strong, expressive mark, or skim it lightly across to suggest a wisp of cloud. Another advantage which pastel possesses is that it is a dry medium – I can work freely and fast with it without having to wait for any drying process.

Disadvantages? A few, perhaps, for the novice. Pastels are very superior chalks (I refer to artists' soft pastels *not* to oil pastels or crayons which are greasy) which are a mixture of pure pigment and chalky fillers bound together by gum tragacanth. The paper surface holds with its 'tooth' or grain the pigment mark made. This can easily be smudged. Likewise some people find difficulty in the initial stages in choosing the exact colour from a range of pastels. In both cases, practice overcomes these minor technical difficulties – one keeps sleeves rolled up so that cuffs do not brush across the picture, and one soon learns to lay pastel sticks out in an orderly fashion and choose the appropriate stick instinctively.

Above all, however, I find pastels an unrivalled medium for colour sketching – not only do they produce a vivid spontaneity but I find a benign exhilaration in painting with them. I cannot think of anything more immediately exciting than to complete a landscape sketch to my own satisfaction, having made, perhaps, less than thirty marks on the paper with little more than a dozen different tints and colours. In this book you will see, stage by stage, how I produce sketches and more finished studio work. What both have in common is my delight in using the pastel medium.

Some artists keep their pastels in colour range and tint in sectioned boxes: I prefer to strip off the outer wrapping paper (first making a note of the colour and tint on a colour chart) and then break the stick into pieces about one inch long.

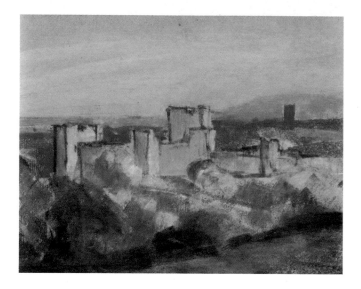

By breaking up the stick I can make with it both lines and broad blocks of colour by holding the stick sideways. As it wears down it becomes faceted, which provides a further range of marks.

To obtain different effects, you not only use the stick to make the appropriate shape of mark, but by exerting different pressures onto the supporting paper you will see how the paper 'bites' most of the pigment, giving a deeper (or lighter, according to the colour of the paper you use) and more intense mark. Practise making marks on different coloured papers.

When I am working in the studio I stretch my Canson or Ingres papers onto a drawing board with a thin wad of newspaper between them. I soak my paper in water, dry it off with towels until damp, then lay it over the newspaper-padded board and tape it to the edges with gummed strip paper. When dry, the paper will be taut over a cushion of the newspaper, which now has a pleasant 'give' when I apply the pastels to it.

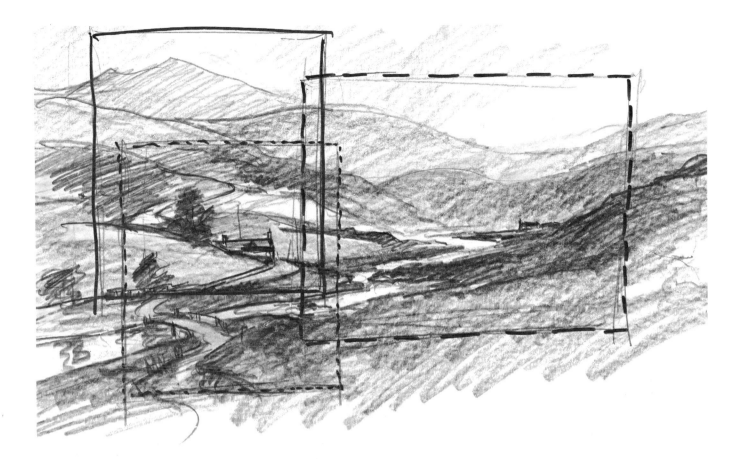

Composition: balance

Always one of the most important considerations in any painting, composition is vital to most landscape studies. Too often I see my students sit down in front of a landscape subject and start to draw and paint straightaway When they see me making several compositional sketches before I start, they take the point! Above is a panoramic sketch I made beforehand for the demonstration on pages 16–17; as you see, I could choose three separate studies from it, the one finally selected is enclosed by the heavy dotted line. Balance your shapes and masses, both linearly and tonally; and find lines that lead into the centre of interest and not away from it.

When you have flat, relatively uninteresting landscape before you, try to find one strong centre of interest from which the rest of the picture can devolve: a high tree, building or church spire. A brook or river wandering through a subject can provide interest, so long as it does not wind from the centre of your picture to the centre horizon! Some people find a piece of stiff card, with a rectangular window cut into it, useful for selecting viewpoints. Hold it fairly close to your eye and you will soon see a portion of the landscape that pleases you and gives you a satisfying composition. Remember, too, scale: what might be uninteresting from where you first view it may be pictorially dramatic if you move to right or left.

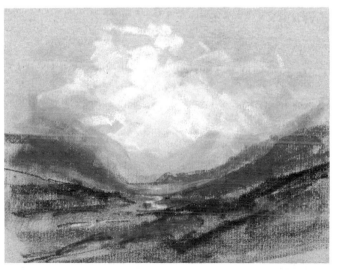

Preliminary study for 'Scottish glen', pages 16–17.

Landscape can be enlivened by the weather. Dramatic clouds, rainstorms, or bursts of sunshine not only provide interesting subject-matter in themselves, but enliven the terrain beneath with light and shadow.

Stage 1

Stage 2

Scottish glen: demonstration

I made a study just as the clouds were lifting from the mountains in north-west Scotland one April morning and when the sun was shining after a period of rain. It was a joyous and uplifting experience to see the blue sky and the sun shining through light clouds.

Stage 1

I select a sheet of light-grey Canson paper, Moonstone tint, and set to work with light tones of burnt sienna, cerulean blue and red-grey pastels, blocking in the basic tints for the sky, with pieces about one inch long, sweeping them across the paper. I indicate the tones of some of the mountains with a stroke of cool grey.

Stage 2

With the cool grey I indicate the basic shape of the glen, and the position of the burn flowing through it, sweeping boldly across the foreground, with a mid-toned burnt umber, I then strengthen the shapes of the near slopes and roughly indicate the buildings, using a dark autumn brown shade.

Stage 3

I shape up the distant and mid-distant mountains with light and mid-tones of cool grey, then with a dark autumn brown and a mid-toned brown, I draw in more strongly the near slopes and add more mid-toned burnt umber to the foreground.

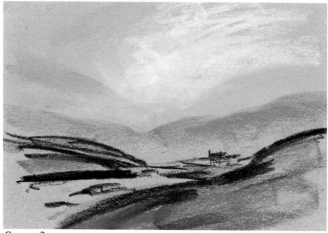

Stage 3

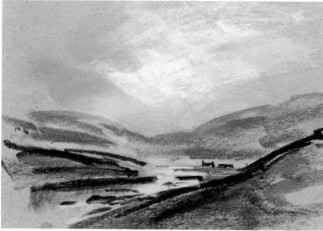

Stage 4

Stage 4

I indicate reflections in the burn from the light sky with pale ultramarine, and with pale brown suggest the light in the middle distance to the left of the buildings. The rocks in the burn are also strengthened.

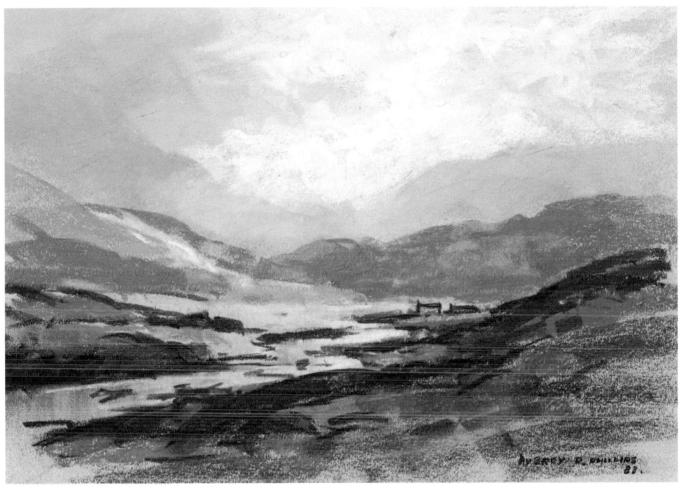

Stage 5 – the finished painting

Stage 5 – the finished painting

I now go over the whole of the picture, emphasising shapes, and with a black conté crayon firm up the drawing of the buildings and the rocks in the fore-ground. I also add a little mid-toned olive green in this area. I further develop the distant and middle distant mountains, shape up the clouds, and the effect of the light from them on the slopes in the left middle distance.

I prefer to leave this picture as a finished sketch, having achieved the quality that I particularly wanted from the subject – spontaneity.

Composition: linear

Another way of determining whether your composition works is to look for the linear aspect. In the picture overleaf on page 18 I choose a viewpoint looking from *below* the focal point (the farmhouse) so that the lines of the mountains converge upon it. Notice how I was care-ful not to place the farmhouse in the centre of my picture – which would have produced a dull composition. Also, I made sure that the rooftops and chimneys stood up against the skyline – again helping to draw one's eye to the centre of interest. The compositional sketch over-leaf shows how the lines eventually arrive at the farm-house – some directly, others following curved paths.

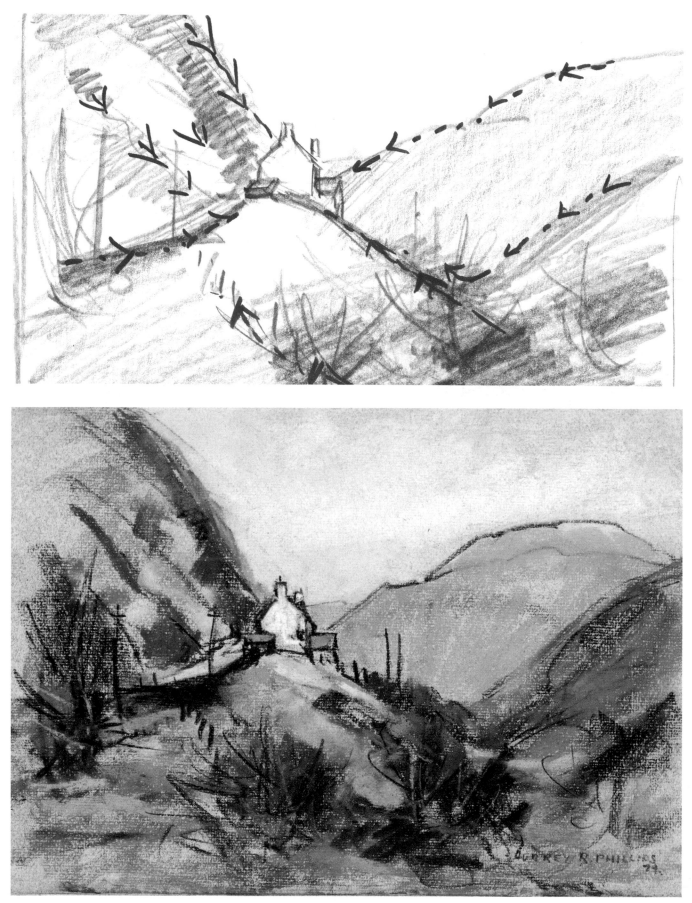

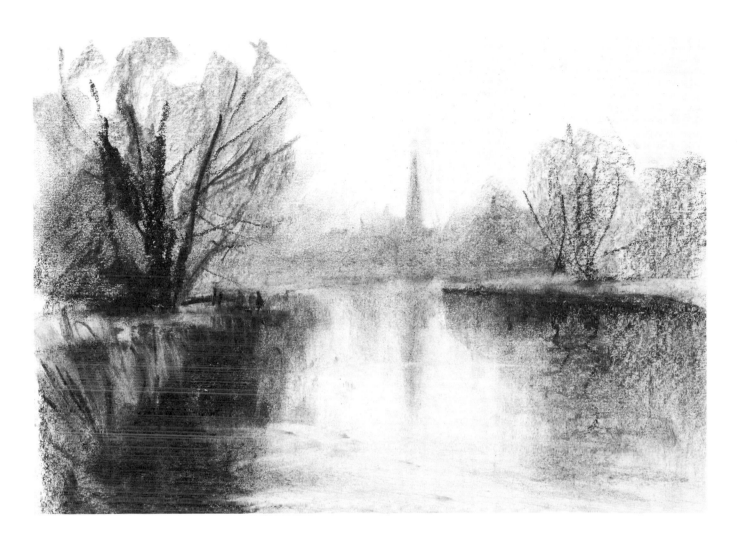

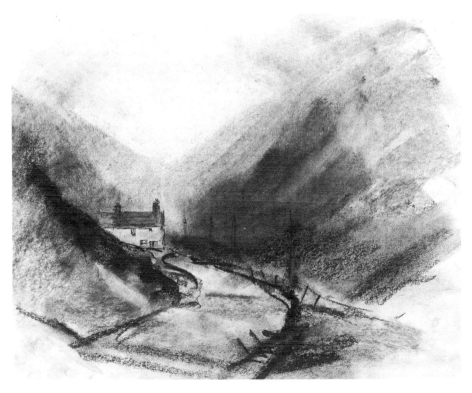

Tonal Studies

Whenever possible I try to make tonal sketches like the ones on this page, opposite and overleaf, before I start to work with pastel. Such studies help me to find the best composition and also to determine the balance of my picture, so that the centre of interest is in the correct place. Normally I use charcoal on white cartridge (these studies are in that medium). Conté, or soft pencil are suitable – use any medium, in fact, which will give you the results you seek.

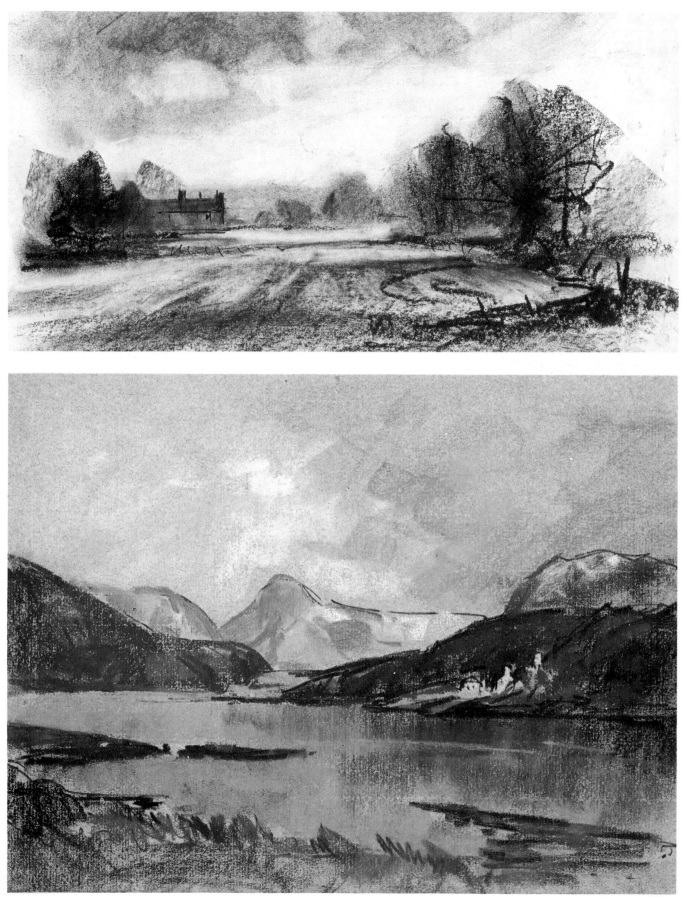

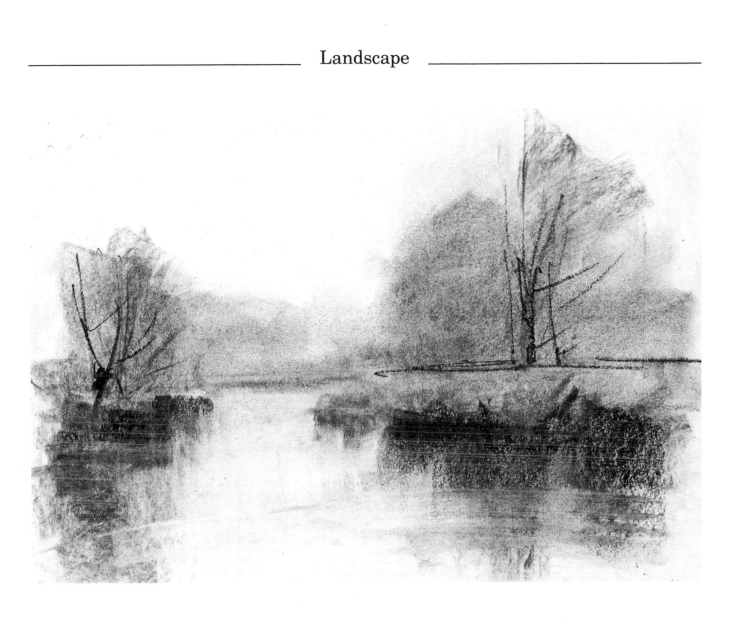

Time of the day

Tonal study in charcoal for the demonstration 'Misty morning on the Windrush' on the next two pages.

Before you go sketching or painting outdoors, it is best to check on the weather forecast, for it will tell you not only what to wear, but probably help you to pre-select (outside your normal range of pastels) other colours which may come in handy. It will also help you choose where to go for, if you already know your terrain, the knowledge that the sky above it will be clear or cloudy will influence the landscape.

I prefer to work when the sun is not at its zenith, for then shadows cast from buildings and trees are short. Early morning or late afternoon brings a drama to the landscape when the sun is relatively low, striking the clouds obliquely, throwing their shadows across hills and plains. Sunrise and sunset colour the landscape and sky with orange and purple hues – here the pastel medium is unrivalled for achieving luminosity.

I sometimes make as many as a dozen sketches and tonal drawings in one day of almost the same subject, observing the light and shade, and how the sun's position changes the shadows. In the next demonstration (pages 22–3) I was fortunate enough to catch the morning mist rising from the river: an atmospheric subject, well suited to a gentler approach with pastels than we have seen hitherto. This picture was painted in my studio from sketches made outdoors. The tonal study in charcoal on cartridge paper (above) establishes the composition.

Stage 1

Stage 2

Stage 3

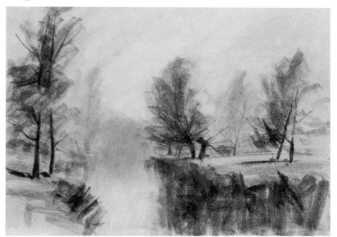

Stage 4

Misty morning on the Windrush: demonstration

In this picture the mood and atmosphere of a misty morning in spring, with soft sunlight breaking through, is my main theme. The setting is a stretch of the River Windrush, in the Cotswold country. I have spent many pleasant hours on its banks at different seasons, and in varying weather conditions, so I arrived there early when I knew the mist would be rising.

Stage 1

I choose a lightish toned pearl Canson paper upon which to work, which will play an important part in the colour scheme throughout. I begin with some bold loose strokes of pale tints of ultramarine and yellow ochre, repeating the ultramarine in the water area, and

use a cool grey for the distance. I put in loose marks of dark green-grey to suggest the reeds on the bank. I use pieces of pastel, about an inch long lengthways, without much pressure.

Stage 2

I continue to work with the green-grey for the tall trees to the left and a middle tone of the same colour between the two trees to the right and also behind and to the right of the left-hand trees. Mid-toned brown is applied for reeds on the distant river banks and left foreground, with more dark green-grey for reflections.

Stage 3

With the same colours I develop the shapes of the trees both to right and left. I now employ a mid-olive green, giving more warmth to the left-hand trees and bank below and over to the right beneath the trees. The trunks of the trees are strengthened with dark brown, the same pastel being used for the river bank on the right. Two other distant tree trunks are added with a darker cool grey and a mid-warm grey.

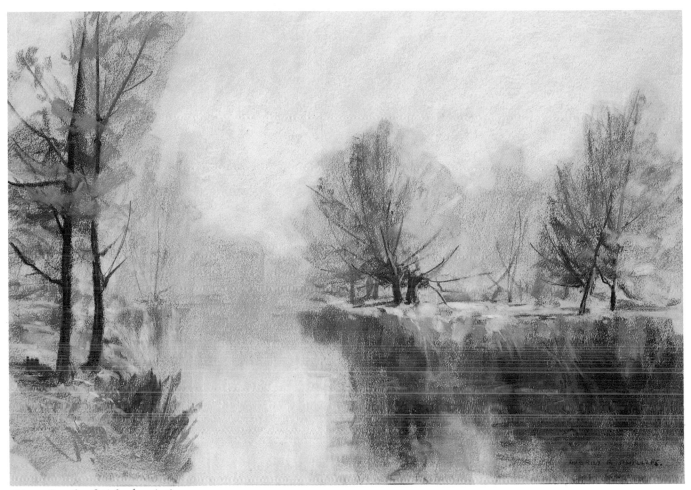

Stage 5 – the finished painting

Stage 4

I begin to develop more form with the same pastels but applying them with more pressure and rubbing them in with my fingers in places, in the distance cool grey and the lighter reflections in the water and the sky. With the edge of the dark brown pastel I firmly draw in the willow tree branches on the right and strengthen further the branches of the two trees to the left, the reeds on the river bank in the left foreground, those on the right and the reflections in the water.

Stage 5 – the finished painting

More paintings are ruined by overworking than by underworking them; it is so easy to go on and on, introducing unnecessary detail and thereby losing the impact. With this in mind, I firmly draw in more detail in the reeds on the river banks, together with the reflections, and touch in more strongly the darker tones of all the trees. Lastly come the light touches of sap and grass greens and the bright highlights of yellow.

This demonstration shows how pastels can be blended on the paper with the fingers, producing soft, pearly effects. But overblending can produce a woolliness that will render your picture insipid – also the colours will become muddy.

Stage 1

Stage 2

Cotswold lane in winter: demonstration

Winter is certainly not a time of year lacking in colour. The dramatic shapes of bare branches of trees seen against the sky offer fine subject-matter; and without foliage views become more open and subjects revealed that would be hidden in summer. The open tracery of bare trees or branches also can often provide foreground features to frame our subject, while a fall of snow changes completely the normal tone values and, if accompanied by sunshine, gives beautiful colours in the shadows, chiefly blues and greys from the sky.

Stage 1

I am painting this demonstration in the studio using a lightish warm grey Canson paper, having stretched it beforehand. I dampen the paper with clear water and, with diluted Indian ink, wash it on with a large flat watercolour brush to give the background tones; the damp paper produces soft edges.

Stage 2

When the first wash is dry, I take a No. 8 nylon brush and, with undiluted Indian ink this time, boldly draw in the trunks and branches of the trees. For the foreground shadows and masses of twigs at top left I again use the flat brush and diluted ink, making them a little darker.

I block in the sky with pale tints of cerulean and ultra-

Stage 3

marine blue pastel, together with a light warm grey to provide an effect of broken colour. I also use a cerulean blue for the snow under the trees. I apply a darker tone of the same grey as in the sky to the background, together with a couple of blue-greys (one of them about the same tonal strength as the warm grey, the other a little darker) to provide the shadows of the foreground.

Stage 3

I add the lightest tint of yellow ochre to the sunlit snow in the foreground and stronger yellow ochre and burnt

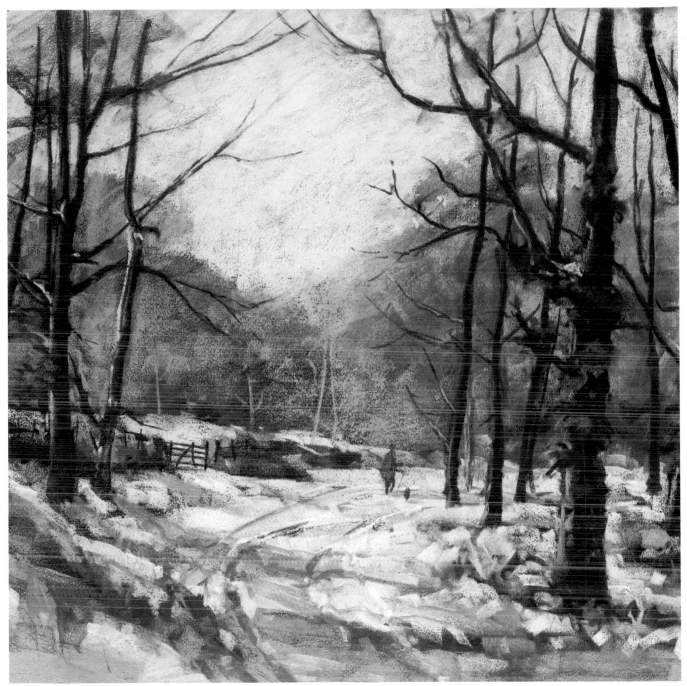

Stage 4 – the finished painting

sienna to the hedge behind the trees on the left and the foreground to left and right. A middle tone of burnt umber is dragged over the tops of the trees to the left, using the pastel flat along its length, to suggest masses of twigs. I apply deep tones of grey and olive greens of the same strength to the near tree to the right, also to those on the left, together with a touch of lighter olive to the right. Some dark burnt umber is added to the trunks.

Stage 4 – the finished painting

Using the same colours, I work over the whole picture, concentrating chiefly on the foreground to create the effect of sunlight from the left. The shadows cast by the trees to the left are an important feature; I use them to describe the ruts in the snow and the rough surface textures. I apply a touch of red to the figure to contrast with the cool colours of the snow, and put in touches of light tints on the trees to indicate snow lodged in the branches.

25

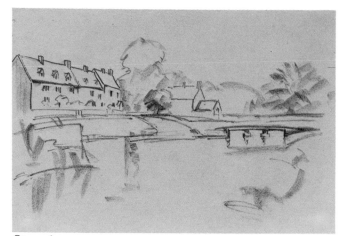

Stage 1

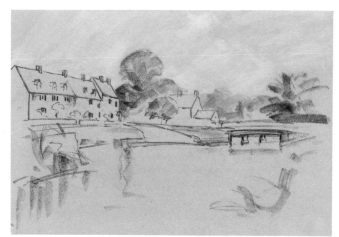

Stage 2

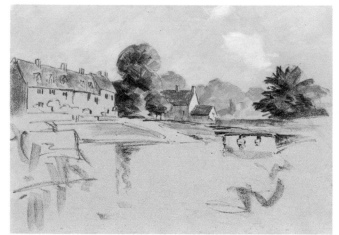

Stage 3

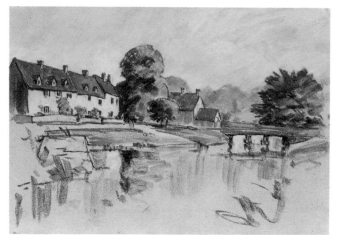

Stage 4

The Bridge, Lower Slaughter: demonstration

Despite its rather off-putting name, this is one of the most attractive of the Cotswold villages, nestling as it does in a sheltered valley in the wolds. The houses' reflections in the clear placid stream which flows through the village appealed to me, so I placed myself opposite them, then worked this picture to its finished stage in my studio.

Stage 1

With a dark autumnal brown pastel I draw in the main shapes on light grey Canson Moonstone paper. I use the edge of the pastel stick to indicate the outlines of the buildings, while for the trees and reflections I apply it generally with the side.

Stage 2

I apply the light tones of ultramarine, yellow ochre and red grey for the sky, again using the pastels flat. With the lengths of the pastels I apply dark green-grey in the shadows of the tall trees to the left, the small one below and the dark tree to the right. A middle-toned sap green gives me the lighter side of the tall tree, the smaller one below and the grass verges. Two mid-tones each of green and blue-grey are used for the distant trees, with a touch of light grass green.

Stage 3

I now lay in lightly mid-brown for the roofs of the cottages to the left, with a darker tone of the same colour on the shadowed gable. Similarly I put in the roof of the other cottage, using mid-raw umber for the wall in shadow and light brown for the sunlit gables and the chimneys. Mid-brown is applied along the wall towards the dark tree which is further darkened with olive green. I use mid-olive green on the tall tree and on the dark one to the right. Light tones of sap and grass greens brighten up the grass areas.

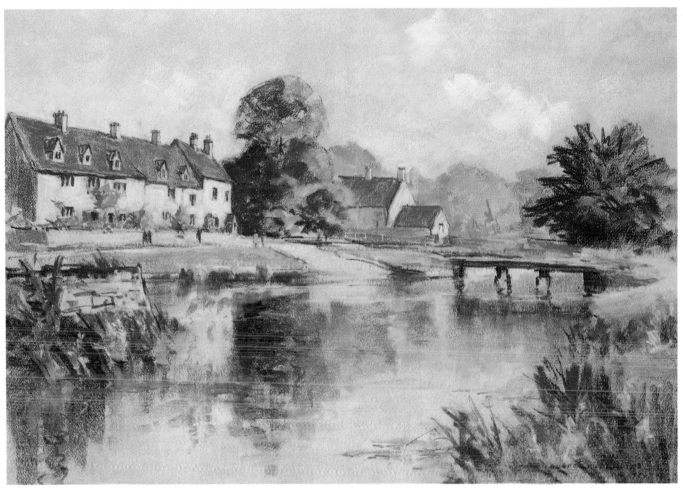

Stage 5 – the finished painting

Stage 4

Using the same colours, I apply them overall, this time with more pressure, and add more detail. I use light brown for the sunlit cottage walls on the left and the stone wall in the water below, with middle sap green on bushes in the gardens. I develop the water reflections lightly with the same colours I used for the trees and buildings above, making downward strokes. I apply light ultramarine under the bridge. I add a little mid-toned red grey to the roof of the middle cottage on the left, then put in the figures. The pathway near the figures is indicated with light and darker red greys.

Stage 5 – the finished painting

The picture is now worked up all over. Rubbing in with finger or thumb (see page 28) in the water conveys a smooth effect. The foreground reeds and wild flowers are stated, but I am careful not to overwork this area as it would detract from the central interest of the picture – the cottages.

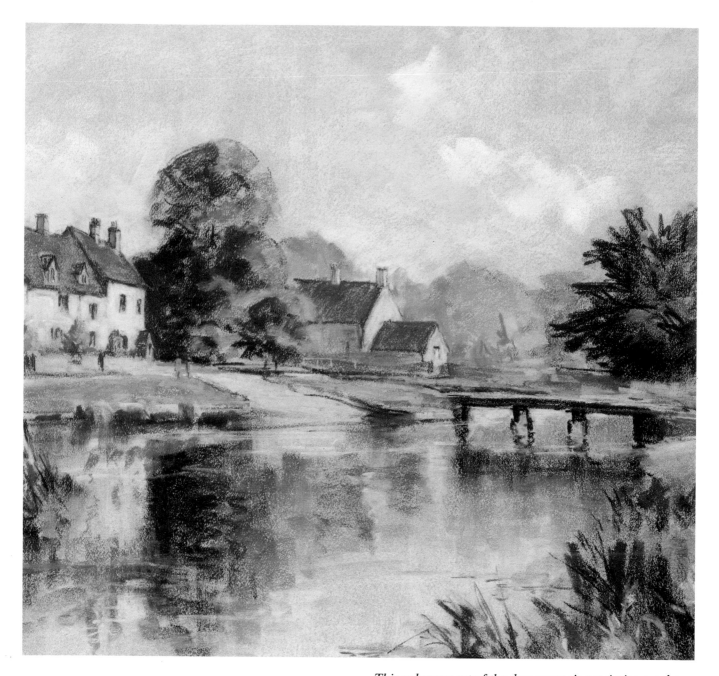

Rubbing-in techniques

While pastel is very effective when the sticks are used directly onto the tooth or grain of the paper support, as in the sketches in this chapter, their effectiveness can be enhanced by contrasting the direct marks with blending or rubbing-in. Water areas and soft foliage can be treated in this way; make your marks on the paper with one or more tints and lines according to what you see, then smooth the pigment into the grain of the paper with thumb, fingertip or a pointed stump or rolled-up newspaper. A few judicious strokes over this rubbed-in area

This enlargement of the demonstration painting on the previous page shows more clearly the rubbing-in techniques used.

with stick pastel will sharpen up features – such as ripples in water, branches of trees, reeds, grasses.

But care must be taken not to overwork this technique, otherwise the painting will become woolly. Techniques are a means to an end, never the end in itself. You will see how I have used a mixture of direct work and blending in the demonstrations, but have not allowed the rubbing-in to dominate the overall crispness of the finished pictures.

I tend to blend or rub-in mostly in the water and sky areas of my pictures which, by their nature, tend to be soft and amorphous.

Stage 1

Pointillist techniques

Among the most effective techniques we can use with pastel painting is to apply the pastel stick to the support or paper by 'dabbing' the end of it rather than by dragging it across the surface. This technique can be related to the discoveries of the Impressionist and Post-Impressionist painters of nineteenth-century France. Instead of painting in brushstrokes the colour of their observations they found that, by analysing colours scientifically, they could place small spots of one colour against those of another, the observed result being a third colour – the one they wished the onlooker to 'see'. The resulting pictures had a vibrant effect not achieved by any other means and can be seen at their most effective in the works or Seurat and Signac. We now know that the evidence on which the theory was based is not strictly

scientific – nevertheless, this pointillist technique has found favour with many painters, and can provide a way of rendering a subject unlike any other.

Pastels are ideal for experimenting with this technique. In the demonstration that follows I have not stuck strictly to the 'scientific' aspect, but have demonstrated how a painting can be built up in this way.

First of all, do stretch your paper over newspaper wadding, as I have explained earlier (page 14). This will allow you to make each small mark without fracturing the pastel stick. Your dots or marks should not follow any particular direction, nor should they be of the same size or shape, as this will make your finished result look monotonous.

Stage 2

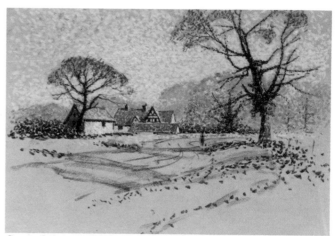

Stage 3

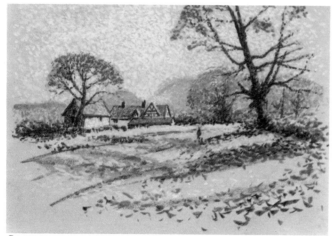

Stage 4

Detail

Worcestershire lane: pointillist demonstration

Stage 1 (page 29)

For this demonstration I choose again the warm, light grey Canson paper called Moonstone. First I draw in the outlines of the main features and indicate the position of the shadows across the road and grass verges.

Stage 2 (above)

Applying the pastels in dots I begin with the sky, using light tints of ultramarine, yellow ochre, cerulean blue, grey and red-grey, together with a mid-toned blue-grey. I then continue with three tones of blue-grey and a dark purple grey for the distant trees. These cool lines are especially helpful when I begin to consider the warm colours of the buildings against them in the next stage of the painting.

Stage 3

Using a number of warm colours such as autumnal brown, a touch or two of vermilion, crimson, Prussian blue and mid-purple grey, I establish a generally warm tone for the roofs of the farmhouse and the buildings below. For the roof of the barn to the left I apply mid and light tones of ochre, with light vermilion. For the darker tones on the shadowed side I use purple grey, Prussian blue and crimson. The shadowed walls of the farmhouse are treated with a warm grey, as used in the sky, and with pale yellow ochre for the light gables.

The trees are stippled in with mid-tones of brown for the twigs and dark brown for trunks and branches. I use open treatment for the twigs, filling in more solidly the trunks and branches and using mid and light yellow ochre for the sunlit parts of the trunk on the right. Dark and mid-green grey with dark olive green are used for the ivy. These same dark greens are repeated at the base of the hedge to the left and in a more open way for a suggestion of the shadows on the grass verges. For the sunny greens I use light shades of grass green and terre verte.

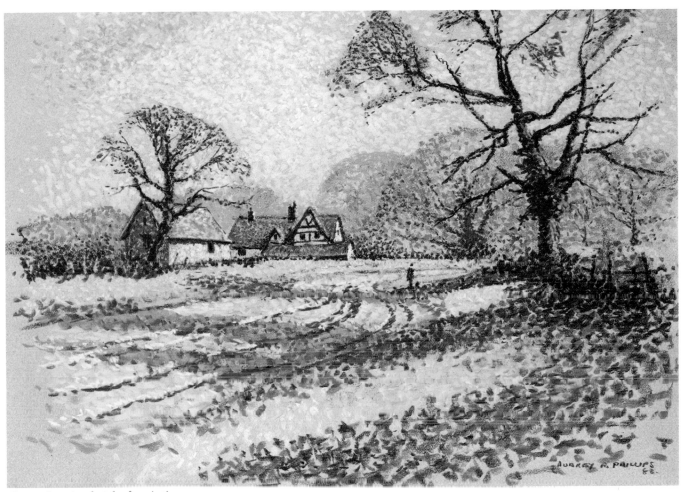

Stage 5 – the finished painting

Stage 4 (page 30)

I continue to apply more dotted pigments to the light and shadow both on the road and grass verges. A range of dark and mid-tones of olive and sap greens gives me the shadows whilst light tints of sap, grass and yellow greens with a few touches of terre verte produce the light. The sunlit passages on the road are a repetition of the sky colours (less than blues), with red-grey mid-tone and a touch or two of dark purple brown.

Detail (page 30)

This same-size detail shows to good effect the shapes of the marks and also how the neutral-toned paper 'binds' them together. You will notice how the actual colours I use are much stronger in hue than those I would employ for conventional sketching and painting.

Stage 5 – the finished painting

I continue working on the foreground area, using the same colours as before, but covering the paper with more dots and making these generally larger in the near foreground to give an effect of recession. I develop more light and shade contrast on the road with light yellow ochre and dark shades of brown and purple grey. I leave a certain amount of paper showing throughout the work to provide harmony.

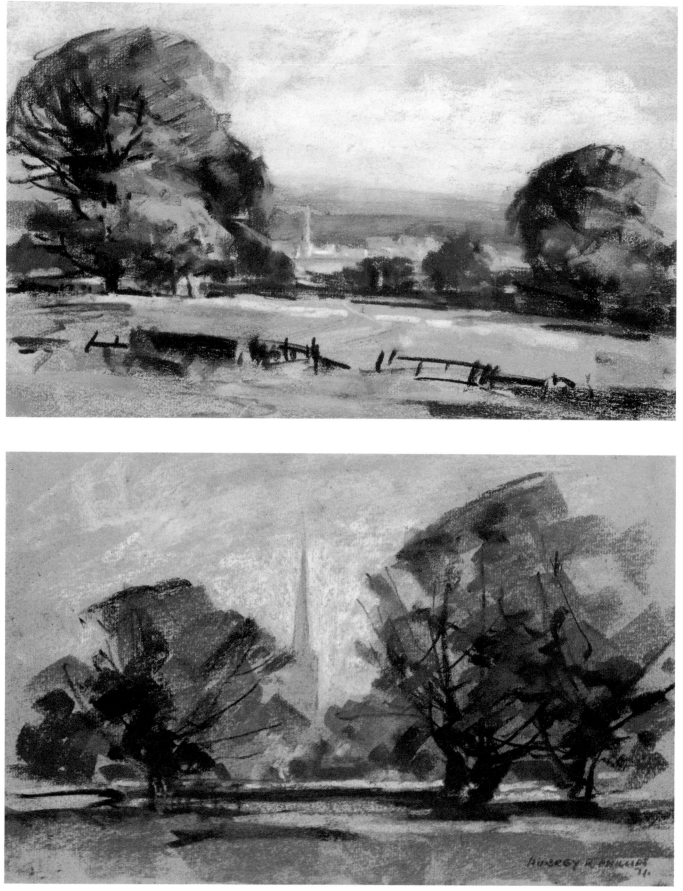

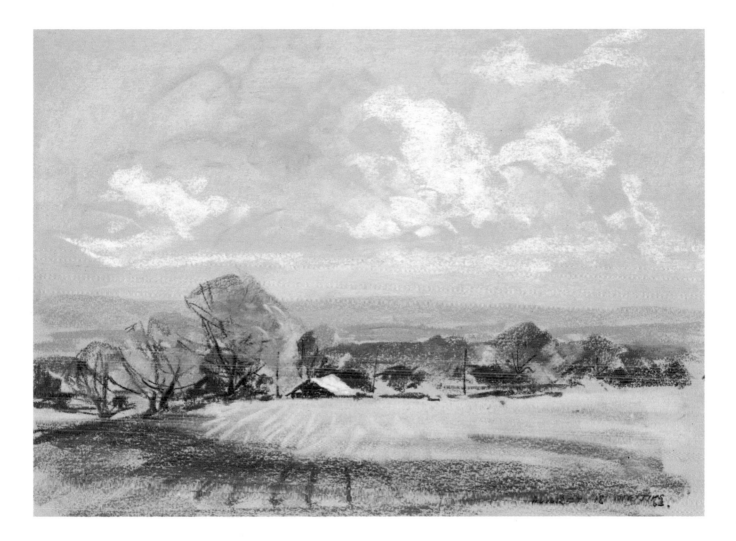

Far and near

Two paintings of the same subject (page 32).

Wandering through the watermeadows beside this Cotswold village I was attracted by the church spire glimpsed between the willows banking the river (*below*). I used a grey sugar paper for this sketch, making bold strokes of broken pastels on their sides to block in the main areas of colour. The dark forms of the trees, particularly the trunks, contrast with the sunlight on the meadow beyond.

Later I viewed the same subject from a few miles away (*top*): perhaps it was accident that caused me to place the spire of the church in exactly the same position! – but this off-centre placing bears out my previously stated maxim that the focal point should not, if at all possible, be put in the centre of your picture.

Sunshine and shadow

Often what might first appear to be an uninteresting subject can often be enlivened by the weather. In this sketch above (which was painted only a few minutes walk from the picture at the top of page 32) I waited until a shaft of sunlight illuminated the field in front of me and also caught the roof of the barn beyond it, thus providing me with a centre of interest otherwise lacking. The lively sky above reinforces the notion of sunlight and shadow.

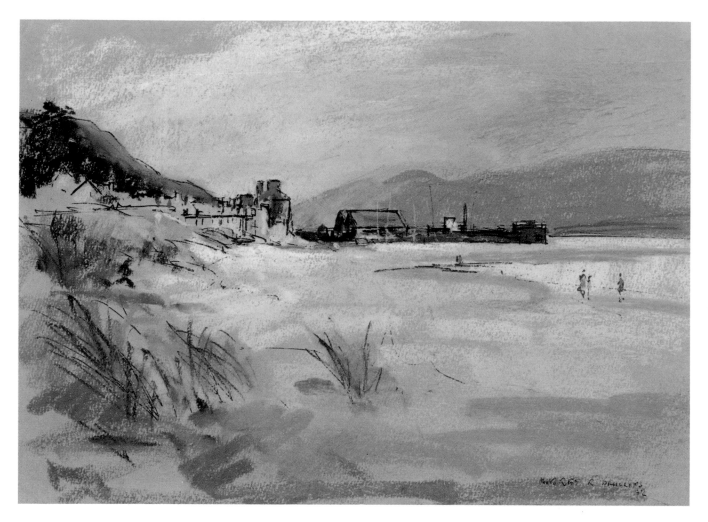

The beach at Aberdovey. *After I made my pastel sketch of this sunlit beach I went over it here and there with fine felt-tip pen in order to strengthen the outlines and pick out detail.*

Mixed media

In the demonstration on pages 24–5 I first applied Indian ink in dilute washes, and then undiluted, to prepare my picture before painting over it in pastel. This is but one way of combining other media with pastel. Charcoal, conté, pencil, watercolour, gouache, acrylic, waterfast felt-tip pens can all be used in combination with pastel, but only at the preliminary stages. One point to remember: any medium that contains grease or oil will never mix with pastel!

In my sketches I will often block in or outline my subject with coarse or wedge-tipped felt pens. The ink dries immediately and takes the pastel painting that follows over it well. Sometimes I will leave this preliminary drawing showing through rather than accent the picture with dark pastel. Remember, if applied vigorously pastel will cover up any underdrawing, for its pigments are opaque.

Some pastel painters will go so far as to paint a complete underpainting in watercolour; then apply pastels over it. Some beautiful effects and textures can be obtained in this way, but the beginner should be wary of the technique before he or she has mastered the different methods of handling pastels.

WATER AND SKIES

by Aubrey Phillips

As I am primarily a landscape painter, I am always fascinated by the dramatic effect of skies, and how they affect the subject matter of the pictures I paint. The lazy drift of broken cloud over the terrain below casts shadows on trees, fields, forests, lakes, the sea: a burst of sunshine minutes later on the same spot formerly in shadow reveals totally new tonal and chromatic values. A lowering sky dramatises what, in more clement weather, would be a gentle pastoral. Falling rain, early morning mists, sun-rises and sunsets — in short the weather that covers the subject of a picture – is an ever-changing and integral part of it. Time and time again I have gone back to a favourite spot to find it changed, by the seasons, and by the weather at that particular time.

Water, too, plays an important part in my picture-making. The division between sea and land often shows nature at its most dramatic; such as when the wind whips up the waves which hurl themselves upon rocky shores, or where a landscape is reflected in the stiller waters of a lake, stream or flooded field.

The pastel medium is ideal for such picture-making. I can work easily and quickly with it, and my equipment is

not cumbersome either in the studio or for sketchwork outdoors.

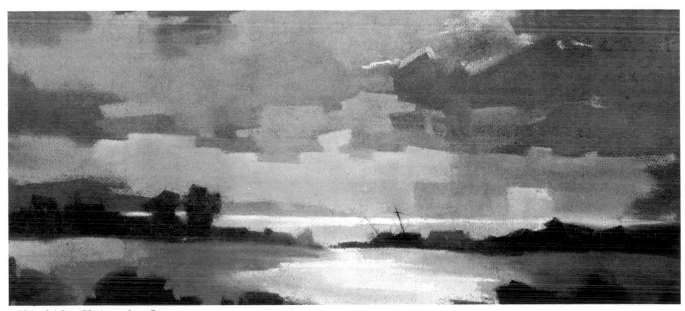

'Clouds' by Christopher Stones.

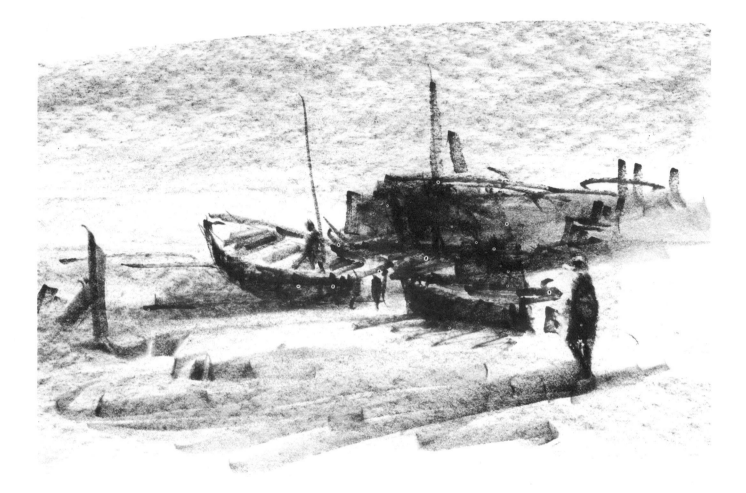

Boats and harbours

As most of us live inland, we often like to take our holidays by the sea or make day trips to the coast, visiting ports and fishing villages. I am lucky enough to have a painter son who has fled the city to live and work in a tiny fishing village in northern Scotland, on the Sutherland coast.

One of the attractions of small ports and harbours is the wealth of functional detail which abounds. Boats, both in and out of the water, provide attractive shapes to enliven a coastal scene. Stone, brick and iron piers and jetties add striking features to one's compositions. If you enjoy painting detail, then the fishing nets, lobster pots and all the impedimenta and equipment related to working boats will give you never-ending material. The working people there wear brightly coloured oilskin suits and sou'westers: likewise their boats are often painted in bright colours. Buildings, warehouses and lighthouses about the shore: even a large industrial port – with its ocean-going cargo vessels, attendant cranes, lorries, trucks and railway sidings – all provide plenty of scope for the artist. But remember, be careful of trespassing. If you particularly want to choose a special viewpoint which might be from a boat or inside a dock, always ask permission beforehand.

Above, and opposite (above): **Sketches of boats, evening.**
Studies such as these are often useful for including in a picture of a beach or harbour, perhaps to give added interest or to provide balance in the composition; or they can be developed as pictures in their own right, with perhaps, the glow of an evening sky behind the broadly treated, silhouetted shapes of the boats. The inclusion of a human figure or two will provide a sense of scale.

These drawings were made with a fibre-tipped pen on white cartridge paper, charcoal being applied with broad strokes for the half-tones over the whole drawing. Lifting-out with a putty rubber produces the light passages and getting down to the white of the paper creates the highlights.

A feature of this approach is that the fibre-tipped pen drawing of the boats, for example, remains undisturbed even when the putty rubber is used in bold strokes across the paper to lift out the charcoal. Some very striking effects can be obtained in this way.

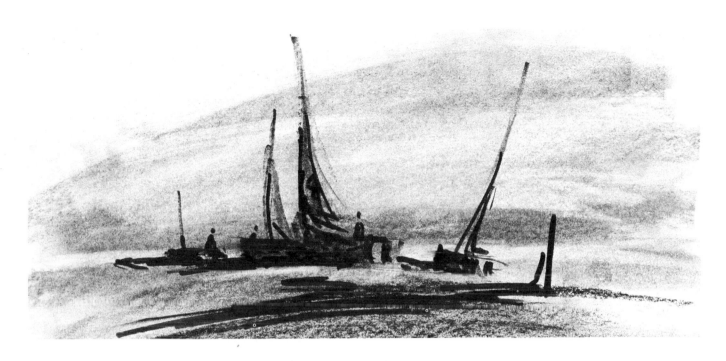

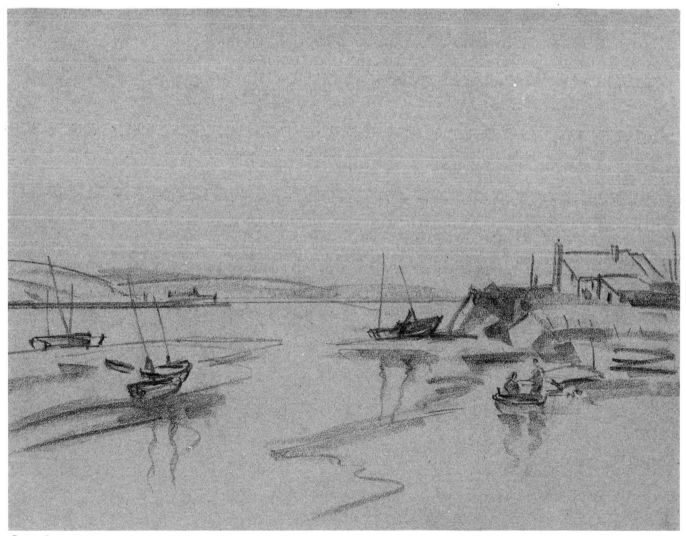

Stage 1 – see next page

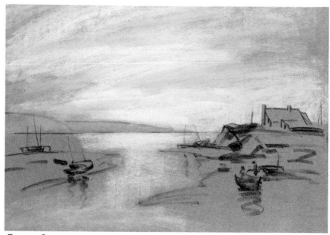

Stage 2

Stage 3

The harbour at sunset: demonstration

The conjunction of sunset and seascape has provided innumerable artists with some of their finest subjects. Turner was obsessed by sea and sky and a large proportion of his studies were made at sunset. For this demonstration I have chosen a typical Scottish inlet. The tide is out, the sun is setting behind veils of cirrus, and an assortment of working and pleasure craft lie stranded upon sandy shores.

Stage 1 (page 37)

As my subject was warm in colour I chose a mid-grey Canson paper with little tooth. Using a broken stick of dark brown on its side I first block in the main shapes very lightly to suggest the main tonal values, then draw in with the same stick the boats, buildings and figures.

Stage 2 (above)

I now work on the sky, using light tints of ultramarine, yellow ochre, red-grey and crimson, blending them together with my fingers to create a soft effect. I repeat these in the sea's reflection, adding pale blue in the creek in the foreground. I apply blue-grey to the distant headland, thus building up the chromatic values of the picture as a whole.

Stage 3

I work more light pink tones into the sky, blending it into the existing pastel with my fingers. I strengthen the distant headland, and use a very pale ochre to suggest the sandy foreshores. I also make the sea reflect more accurately the sky colours.

Stage 4

Stage 4

The sky has caught the headland in the middle distance, so I add touches of light crimson and light yellow ochre. I block in the grasses on the left and right of the picture with mid sap green, and start suggesting the darker foreshore tones with mid-burnt umber tint. I use the same colour for the cottage roof, adding blue-grey to the roofs of the outhouses attached to it.

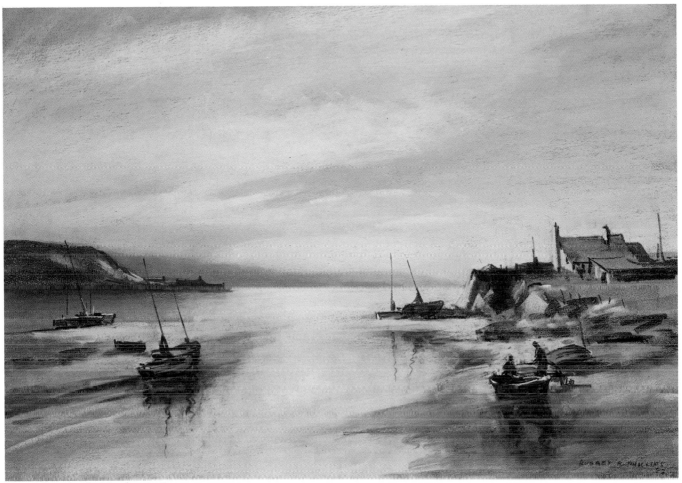

Stage 5 – the finished painting

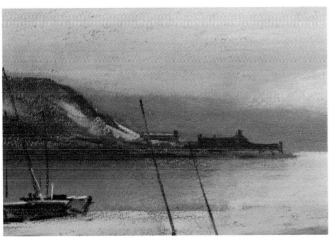

Detail

Stage 5 – the finished painting

I now put in the chromatic accents of the picture in strong lines of crimson, orange and Prussian blue, draw in the figures almost as silhouettes and add brighter touches of light sap green to the grasses. I add reflections of the boats in the still water, and the muddy strand to the right. A little olive green is added to the foreshore. Lastly I go over the whole picture with touches of autumn brown to crispen up the details, and strengthen the rocky promontory above the figures.

Detail

I have picked out this area to show where I blended the pastel tints with my fingers, and where I deliberately made strong pastel strokes.

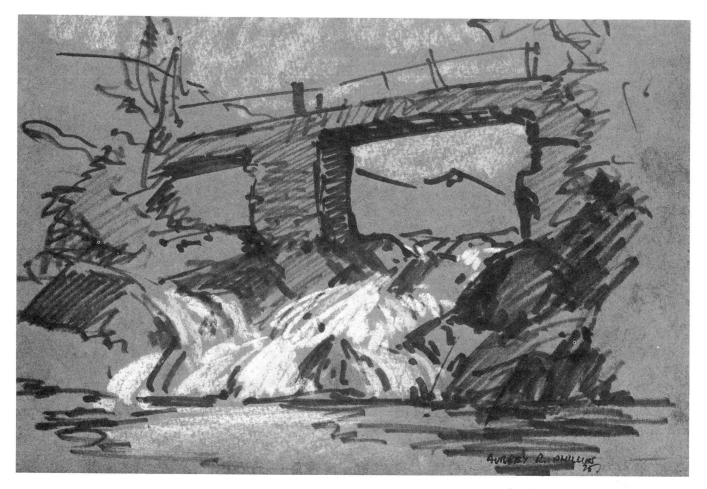

A sketch of a bridge and waterfall

Moving water

When painting water in motion, a whole new dynamic presents itself. The water's surface is broken up into ripples, wavelets, breakers, spume. Its fluidity is torn apart by the wind, by rocks as it tumbles over them or as it dashes against a rock-strewn seashore. The colour we see in moving water comes from itself, if it is muddy; from the sky, as its numberless facets reflect the lighest part of your chosen study; and from the ground beneath it. Only occasionally will the water reflect, mirror-like, the objects above it and these only in crazed half-glimpses. Even the stillest water sometimes has a band or light streak across it, breaking its mirror-like surface where a zephyr has lightly cuffed it. The minute ripples caused by the puff of wind make their surfaces reflect the sky. Magnify and complicate this effect with gravity (waterfalls and rapids), drag your water over rocky surfaces, push it against cliffs and it virtually becomes another substance altogether for the artist to depict.

The biggest problem when drawing or painting moving water is that one can never 'freeze' the motion, as in a photo. Do not try. Sit and watch it, and analyse the predominant shapes and colours as they almost re-form time and time again. No two waves are the same, but a study of fifty will tell you what a wave looks like and you will be able to incorporate it more surely into your picture.

Try to 'feel' the movement in your hand and arm when making your pastel marks. Be as bold as you dare – in this way you will render more convincingly the mood of your subject.

'I begin to block in broadly, without detail . . .'

Detail 1

Waterfall: demonstration

For this study (page 42) I started drawing in with a fibre-tipped pen on a fairly deep-toned, buff coloured paper, which I thought was appropriate, because the subject, apart from the water, was itself low-toned. The lighter, bright passages of the water and the distance would, I felt, be enhanced by it, as would the sunlit effect breaking through the trees. Fibre-tipped pen enabled me to establish the sharp, clearly defined shapes of the rocks, especially as they occurred against the light water and sunlit areas.

Detail 1 (above right)

Here you can see how the brown-toned paper is left untouched by pastel pigment in places. Notice too how I make my marks – I do not draw with the pastel sticks but make expressive strokes to vitalise the picture surface. This detail is taken from the top, to the right of centre.

Detail 2 (right)

Lower centre: the water tumbling into the rock pool. This is the brightest part of the picture: only here have I used a strong white accent. Most of the waterfall is depicted in cool greens and greys.

Detail 2

I begin to block in broadly, without detail, the positions of the rocks and trees (*see sketch, above*) establishing clearly defined shapes and paying particular attention to the composition. Next I apply the pastels, dealing first with the distance in the upper part. Here I use light green-grey and the middle tones of blue-grey, suggesting the shapes of trees. For the nearer trees I apply three tones of olive green with a few touches of light sap green for the bright sunlit parts. These same colours were carried down on to the grass covered rocks below. For the dark tones of the rocks and nearer tree trunks I select a deep tint of autumnal

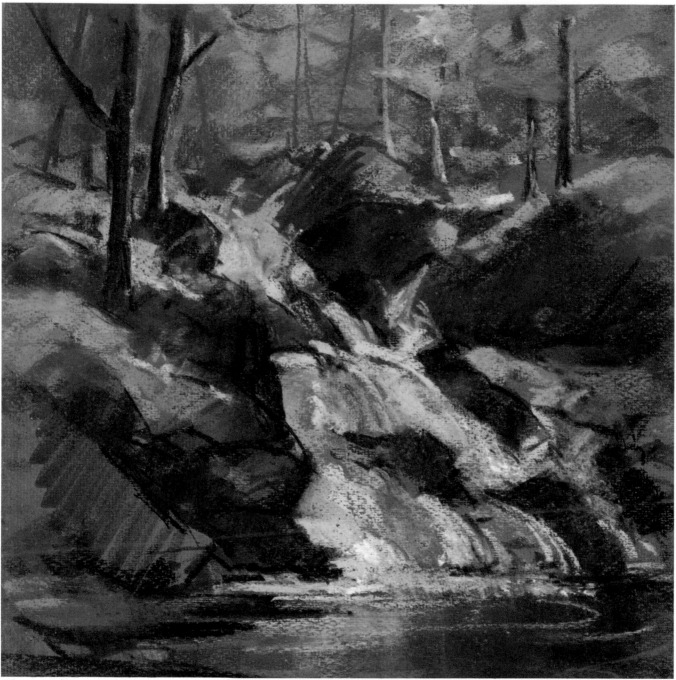

The complete painting

brown. The light tones of green- and blue-grey in the distance were repeated in the falling water, with the addition of pale ultramarine and a few touches of white for the highlights. Brown and light green- and blue-grey provide the colours of the pool at the base of the falls.

To create the smoother effect of the rock pool with its reflections, I apply the pastels with downward strokes, before rubbing in with the thumb. The ripples are then drawn over the top with pale ultramarine and blue-grey. This, then, completes the picture as far as the pastel work is concerned but certain strengthening still needs to be done. As it is not possible to draw

with broad fibre-tip over pastel, I use a stick of black conté to sharpen up the drawing of the rocks and the nearer tree trunks, adding emphasis where required.

The warm colour of the paper has been allowed to show through and it plays quite an important part in the colour effect, as I had hoped it would. The pen work, too, shows in certain passages. About ten colours were used in the picture, including light greys and white, but I was careful not to use too much of the latter or a rather chalky effect would have resulted. The deep tones of the rocks made the colours of the falls appear lighter by contrast.

Skies

Skies and weather have a strong emotive impact on what we perceive when we go about our daily lives: they affect us emotionally and physically, the subject is part of our everyday conversation. No wonder artists are quick to incorporate the mood that the weather and sky impart into their outdoor pictures.

Before you go out to paint or sketch, check the weather reports on radio or television: the forecast will help you to determine not only what equipment you will need but suggest the most suitable clothing to wear.

The sky colours and affects both landscape and seascape. John Constable's colour sketches of the sky are small masterpieces of observation, both in substance and mood. The sky influences the ground beneath, so study the sky above your subject and relate it to what you see below. Not only will it help you choose your composition but, by observing wind direction and waiting for the drift of cloud, patterns of sunshine or shadow, you can choose your moment to make the best of your subject.

Cumulus, nimbus, mackerel sky: all these lend dramatic effect to your picture. When I go out sketching I usually know the topography of the subject I wish to depict. The unknown (and surprising) element is the effect the sky has upon it. There is no such thing as *bad* weather! Indeed some of my most dramatic pictures have originated from sketches made in pouring rain!

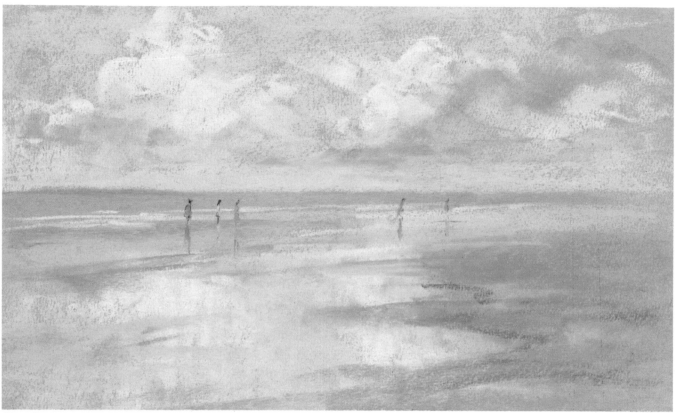

Beach scene: summer

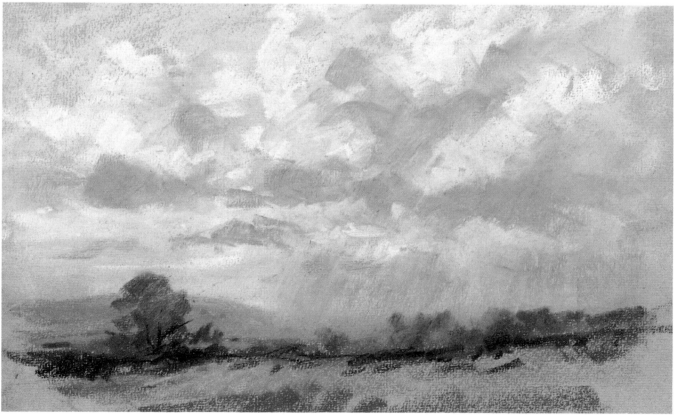

Stormy weather

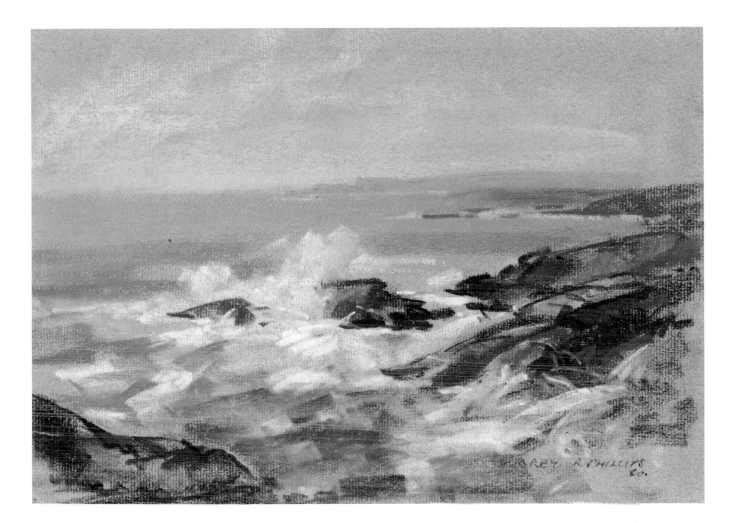

Skies

Beach scene: summer (opposite, above).

This painting was an attempt to convey the atmosphere of a fairly calm summer day with a limited palette of soft tints, but I made use of the cool, pale ultramarine background for the sky with the grey-green sea contrasting with the warm greys, red-greys and pale burnt sienna I used for the sands.

In a subject such as this we can see quite clearly the inter-relationship between sky and landscape, with the clouds and blue sky reflected in the tidal pools on the sands.

Stormy weather (opposite, below).

Here I depict, on Ingres Fabriano blue-grey paper, a stormy effect with dark undersides to the clouds and those at a lower level wholly in shadow, together with a rainstorm on the right of the picture. In order to convey the impression of rain falling over part of the landscape area, I applied mid-toned pastels on their sides, using downward strokes, thereby softening the edges of trees in the middle distance.

Rocky shore, Sutherland

Rough seascape was overcast with cloud, and the breakers were rolling in to crash in spume on the rocks. I sat for quite a while just observing, watching each wave break and recede before I made up my mind which moment I wanted to catch. I chose but a few colours – greens, blues, greys, dark crimson and Vandyke brown. The paper is the grainy side of a sheet of grey Canson. I wanted each mark to express the vigour of the scene, so I used broken sticks on their sides in short, powerful strokes, overlapping them in places.

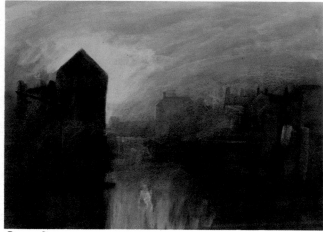

Stage 1

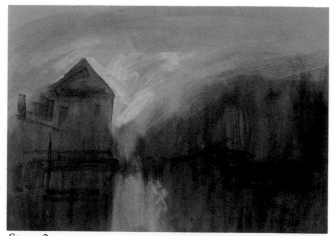

Stage 2

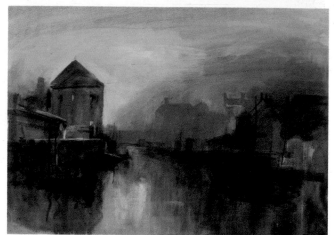

Stage 3

Stage 4

Night scene: demonstration

When daylight is ended, most painters, both professional and amateur, put away paints and pastels to carry on other activities. But there are occasions when, with the moon at its brightest or streetlights and illuminations from windows in houses and factories gleaming in sharp or occluded glow, a dramatic picture presents itself to us. Photographers have rendered the night scene so effectively that we accept their pictures as commonplace in illustrated magazines and books. I sometimes think it a pity that artists lag behind photographers in this respect.

This is a composite picture which I made up from memories of visiting an old fishing port.

Stage 1

I choose a light pearl grey Canson paper and stretch it on a drawing board as for use with watercolour, this being necessary to prevent cockling for I intend to apply ink washes to it. Using Indian ink diluted with distilled water and a 3-inch flat watercolour brush, I boldly shape up the tall building on the left in a fairly dark tone, carrying the wash down to the bottom of the paper. Adding more water to the ink, I now apply the lighter area to the right, softening the edges with a sponge but at the same time leaving the shape of the left-hand building fairly clearly defined, except at the top left, which I again soften with the sponge. While the ink is still wet I set the drawing board at a slope of about ten degrees and add more ink to the right, using a rather darker tone than before. I now leave the drawing board in position and allow the ink to dry.

Stage 2

The preliminary dark washes of ink have given me a strong basic tone upon which to work, helping me to create a night-time atmosphere. I now begin to apply the pastels in pieces about an inch long used on their

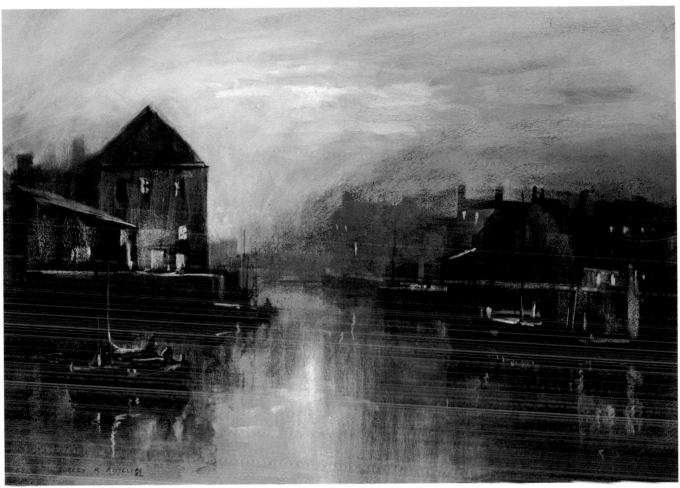

Stage 5 – the finished painting

sides. Firstly, I use light ultramarine against the edge of the tall building with a grey of a slightly darker tone to the right and a yet still darker tint along the top of the sky (which is repeated in the water). A light touch of yellow ochre indicates the position of the moon, and its reflection in the water. I apply dark and mid-toned green-grey to the water, which I rub in with my thumb. I lay in now a dark purple grey with a dark brown to suggest freely a few shapes of the boats.

Stage 3

I further develop the sky, bringing in more light around the building on the left to give contrast, and follow with silhouetted shapes of blue-grey for distant buildings. Next, I introduce warmth into the picture with some mid-tones of burnt umber and Vandyke brown. Mid-warm grey and a little pale blue-grey suggest a feeling of soft light to the right of the distant buildings.

Stage 4

I now firm up the shapes of boats and buildings, introducing vague figures. With touches of mid-Vandyke

brown I develop more form particularly on the left. The touches of light which I am now adding would not register anywhere near as bright on a lighter toned paper as they do on this background of dark ink.

Stage 5 – the finished painting

A general pulling-together of the whole composition now follows, the boats and buildings being worked up into more definition. I try not to lose the feeling of mystery and softness of my night-time subject. Brighter spots of colour, reds and greens of navigation lights on the boats and lighted windows complete the picture. The water of a harbour is never still, so the reflections of the lights in the picture become vertically elongated.

47

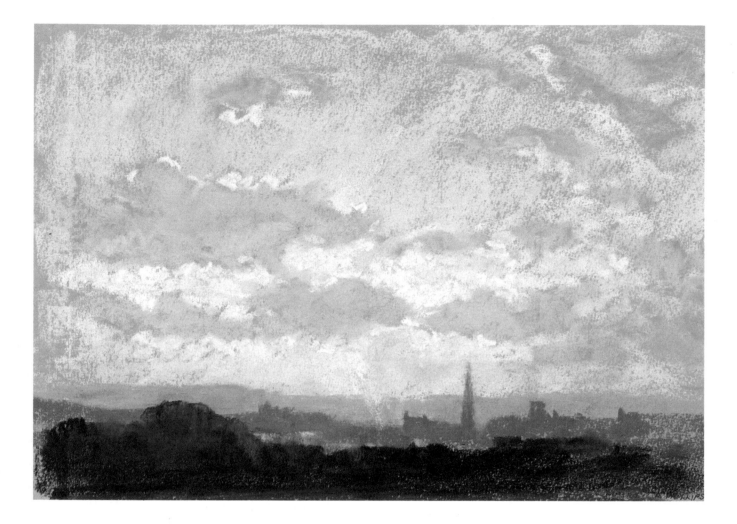

Silver lining

This is the type of effect which we see early in the
morning or during the late afternoon as we look
towards the sun when it is low in the sky and partly
hidden by broken cloud.

The greatest problem in dealing with this kind of
subject is how to express brilliant light. The lightest pig-
ment which we have at our disposal is white, so we have
to adjust all the other tonal relationships in order to
make the uttermost use of this light. In this study, the
middle-toned grey Canson paper helped from the begin-
ning. I use the medium tint of cerulean blue for the
background and a darker grey for the clouds. The light-
est clouds were pale yellow ochre with touches of white
for the lightest parts and a little pale burnt sienna just
above the horizon. The distant landscape was put in
with a mid-toned blue-grey and a darker warm grey
against it, with the darkest tone of sepia for the fore-
ground. This darker passage helps to give contrast
value to the lighter tonalities.

STILL LIFE AND FLOWERS

by Aubrey Sykes and Christopher Stones

Text and demonstrations by Aubrey Sykes

One of the great advantages of still life is that most of the subjects can be found in our own homes. They do not move about as in life drawing, nor are we dependent on the vagaries of the weather, as in landscape painting; so the artist has the opportunity of observing and portraying them without disturbance.

The still life 'seen' may be better than the one 'arranged', but this needs some explanation, for it is truer to say that the still life 'seen' is better than the *badly* arranged group. There are certain indefinable qualities in a 'seen' still life which you cannot reproduce by arranging a group however hard you try. I admit, many masterpieces exist of arranged groups but to my mind they do not compare with an inspired reaction to the appearance of something seen, something which does not require adjustment. You have only to look around your own home to see what I mean.

The casual throwing of a coat over a chair, the collection of items on a kitchen draining board, children's toys left abandoned, all these are there to be observed before one tidies the place. I am not suggesting that you become untidy, but do look around before disturbing something that could eventually be the inspiration for a picture – and, what is more, do not just look: do something about it! Many of the paintings of Van Gogh and Cézanne were of something seen rather than arranged, even though both painters did not hesitate to make adjustments to their pictures if they felt it necessary. It is however, the experience of arranging which educates the eye to see the beauty which is around us.

We have to cultivate a 'seeing' eye by knowing what to look for. This can only be achieved by practice. The trained eye is always looking and comparing one thing against another. Using a sketch book is the best method of remembering what we have observed.

Often a particular light governs whether we like a setting or not; sometimes a change of light will create the requisite conditions for an interesting painting from the most ordinary of subjects. The play of light coming through a window or an open door can stimulate interest to the least experienced eye, and perhaps the desire to paint.

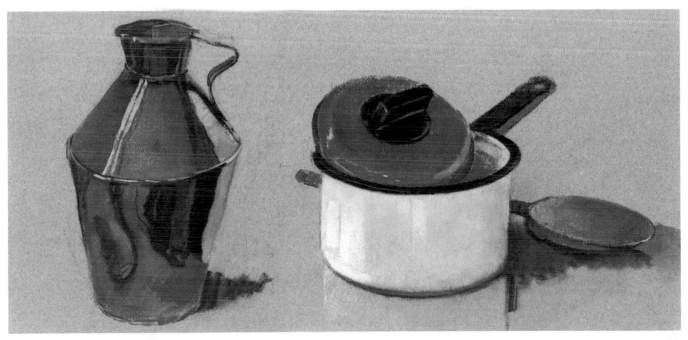

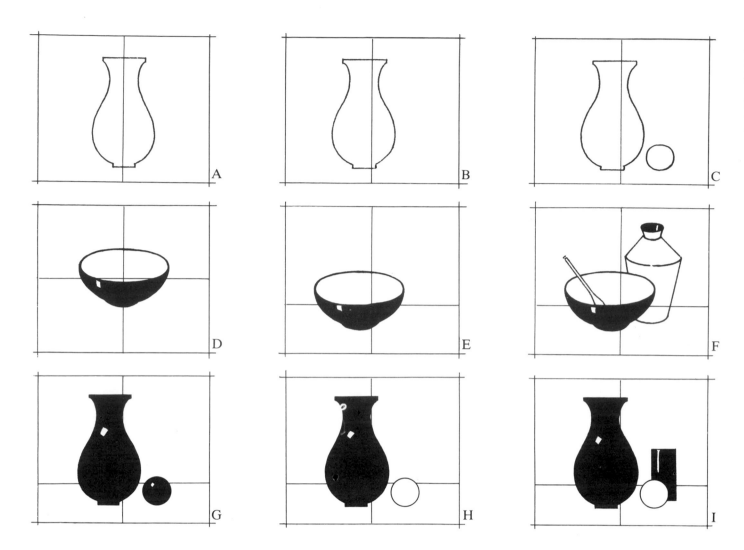

Composition

The shape of the paper on which we work affects the arrangement of a group enormously, but whatever the shape or size the placing of a dominant or important object exactly centre will always look awkward and uninteresting as at (A) above. This divides the background into two identical areas, not as interesting to look at as two dissimilar shapes. From this we may deduce that similarity of shapes, lines, tones or colours will tend to produce a feeling of monotony.

The diagrams illustrate these points:–

Although the composition has been helped by placing the vase to one side (B), a smaller object or foil, the ball, has been introduced to counterbalance the vase to the left (C). In position (D) moving the horizontal lower and (E) the dish to the left has achieved a decided improvement. Including the milk can on the right and the line of the spoon on the left (F), now gives the overall appearance a comfortable balance.

Composition is not solely concerned with the linear aspect; tone, or the weight of the tone distributed throughout the picture, has a considerable bearing. The placing of these 'weights' happily within the picture area is a skill acquired, perhaps, more by experience than by any particular set of rules. However, the word 'balance' implies a situation where the secondary object merely anchors the dominant feature and prevents it from being overweighted in the other direction.

While equal areas often appear monotonous in juxtaposition, tone seems to exaggerate this. By placing one object against another of similar tone, the overall harmony or balance is disturbed. In (G) the tonal weight of the vase is projected into the right-hand half of the paper by means of the black ball and there is a feeling of balance, but this is not so in (H) where the tone has been removed from the ball, throwing the picture balance back again to the left. The harmony is again restored in (I) by the introduction of the small black vase to the right.

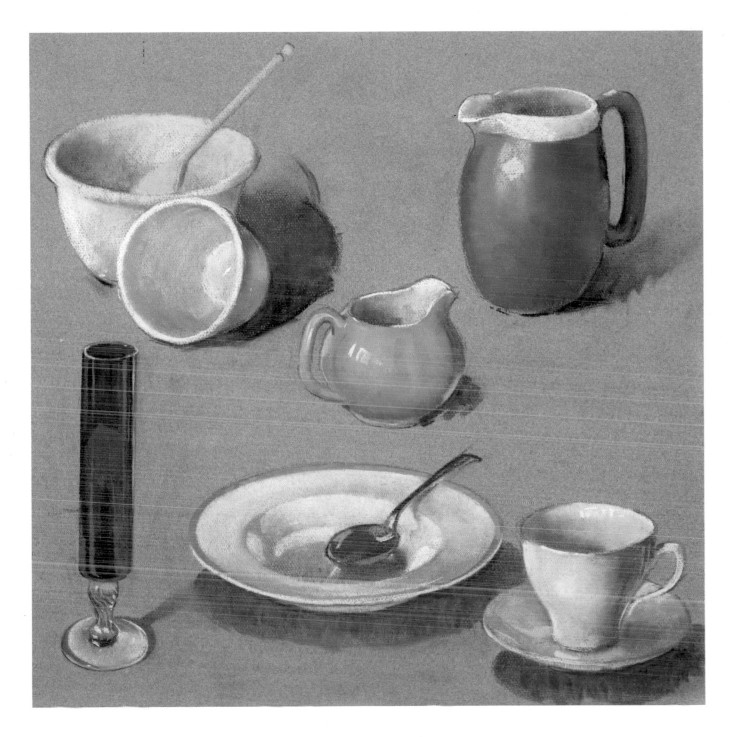

Common objects: demonstration

The objects we see around us every day form the basis of a large proportion of still-life subjects.

Before we can think in terms of a group it is necessary to draw objects individually. Each object has its own shape, colour and tone. To be able to sit in the comfort of one's own home and concentrate on a single item, without taking too much notice of adjacent impedi-

menta, can help the beginner who is trying to master the art of pastel.

Having studied and painted these forms separately, you have, of course, the problem of binding them together to form an artistic group, which involves composition (see opposite). For the moment, let us examine, in detail, the individual items concerned.

Generally speaking, there are three main groups: the *Opaque* such as plates, cups and saucers, jugs, wooden objects, etc.; the *Transparent*, such as bottles, glass vases, in fact anything made with glass; and lastly, *Metal* objects, which reflect light (see page 49).

Textures

By applying the medium in different ways a variety of textures is obtained and character given to the painting. You may use all of these methods (shown here) or the particular one which you find most suitable to your own requirements, singly or together.

Cross-hatching is rather like the warp and weft threads in a piece of material; the more coarse the line you use the rougher the result will be. Then there are lines adjacent to each other or in juxtaposition, both vertical and horizontal, giving a very different effect. The end of the pastel or the broad side may be used, to produce a finer or a coarser line.

Pointillism, the placing of coloured dots against each other, relies on distance from your drawing to produce the desired effect.

Lastly there is the rubbing technique, which makes use of the grain of the paper. This method is almost a painting approach as opposed to the former styles which are allied more to drawing.

Some objects may be better described in a certain way. For instance, stone jars, plates, cups and saucers, all being solids, respond better to the rubbing method, with perhaps a little line work superimposed. On the other hand, cloth and other materials are better when a less opaque and a more open technique is called for, except in the highlights. In fact the high-lighted area of any subject is best treated in a much more opaque way than the shadow portion. To obtain this opacity we either rub or press very hard on the pastel.

The roughness or 'tooth' of a paper also creates texture as in the half-tone (right). Renoir even used canvas as a ground, while some artists use sandpaper.

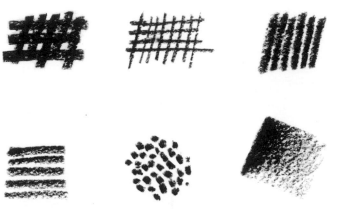

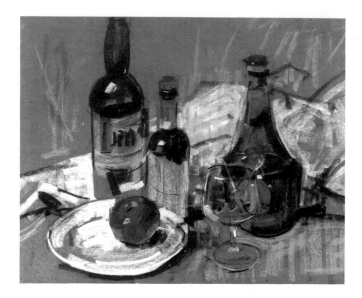

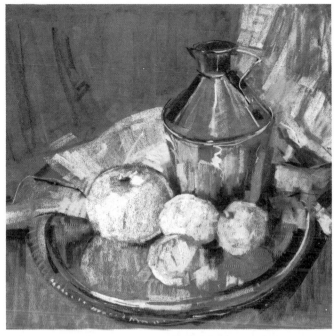

The contrast between a rough finished pastel

and a smooth finished painting

Finish

The word 'finish' usually refers to the degree of attention given to the actual working of the pastel in its final stages, such as the amount of softening of edges and the subscribing to detail (or over-subscribing as the case may be). Strictly speaking, the amount of 'work' is deemed sufficient depending on how far the artist wishes to take the final stage of the painting. It is unwise to over indulge in detail or the process of softening until one has the necessary discipline and restraint in one's armoury, like the Dutch masters who knew how to prevent any detail spoiling the unity of the whole picture.

If only a sketch is required then you complete or finish it at an early stage, often necessary for lack of time or the need to obtain an effect quickly, for example, fleeting light. A thorough examination of the subject will require more detail – more tones and colours, more variety of planes – in fact the more we do, the more 'finish' we are adding to our painting and it becomes, progressively, more subtle and difficult. It is easy to over-work a pastel but it is just as easy to underwork one. The underworked pastel is usually very thin, relying, as it does, on understatement and slickness; an over-worked one, on the other hand, becomes a 'pudding' and so loses all character. Something between the two, therefore, is the result to aim for. Sufficient tooth must be retained in the paper to enable the final work you apply to be superimposed in the final operation. The rule here is 'Don't rub in too much thickness of pastel in the early stages', never lose the tooth or grain of the paper until the final accents and highlights. Should it become overloaded with pigment, as can happen, dust off the surplus with a hog-hair brush and redraw the offending passage, only this time be more careful! Luckily, the pastel medium is an accommodating one.

Bottles: demonstration

Bottles, individually and collectively, contain rich colours, the strange distorted shapes seen through them are always fascinating, and portraying transparent glass and its reflecting surfaces is a challenge to the artist.

The paper colour for your pastel picture depends very much on the contrast you require for the lights coming through the bottles. It should not be too pale but, apart from that, choose the colour you feel goes with the group. If you place an identical piece of paper behind the still-life group itself, this will indicate the correct relationship between the various tones and colours of the pastel sticks you use.

Stage 1 (page 54)

The drawing stage is completed and a certain amount of dark colour is drawn lightly across the paper – rather feeling my way. I had decided that the group looked more interesting if I took the neck of the champagne bottle above and out of the picture area, and allowed the rest of the group to be drawn that much larger.

Stage 2 (page 54)

I next produce a strong emphasis on darks which is desirable because of the intense depth of tone in each of the bottles. I place the darks first, for then I know the absolute or maximum depth of tone available to me.

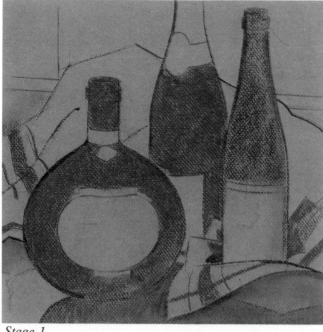

Stage 1

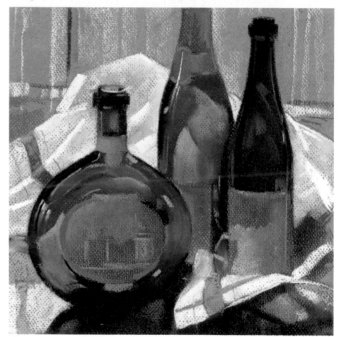

Stage 2

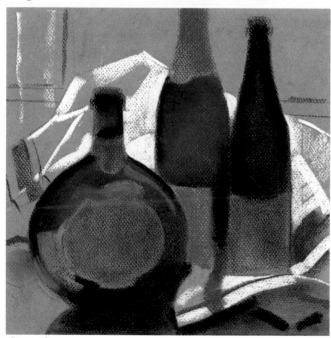

Stage 3

Stage 4

Stage 3

I next establish the lightest tone, which is the napkin. I now have the maximum and minimum of dark and light; all that is required is the painting of the areas between these two extremes. Painting in the white napkin at this stage also gives me the true value of the background tone. As it will have a considerable influence on the final result, I state it as soon as possible.

The build-up of the picture must be gradual to avoid mistakes. If one does occur and, after brushing out, a return to beginnings is desired this may be completed by the gentle application of a putty rubber, but only *after* the brush has taken off all the surplus pigment.

Stage 4

Further half-tones, details and highlights build up towards the final stage. By drawing with dark colours I emphasise the strange shapes seen in the bottles.

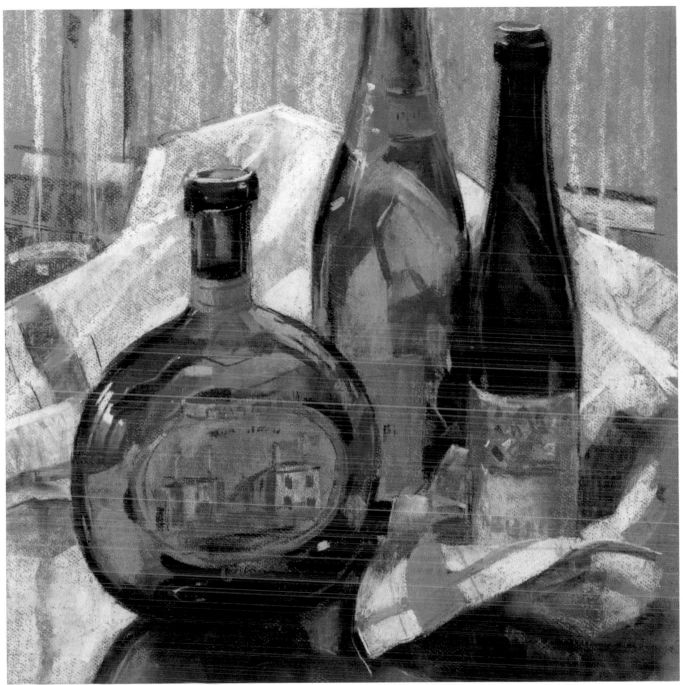

Stage 5 – the finished painting

Stage 5 – the finished painting

A certain amount of rubbing or adjusting the contours and edges is needed before finally placing the detailed highlights. I add the background, draw in the labels and give more form to the napkin.

Have you noticed the usefulness of the green line on the napkin? Apart from their decorative value, stripes are useful to describe contours. Converging lines also aid the feeling of recession and give depth to a picture.

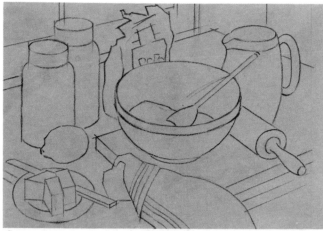

Stage 1

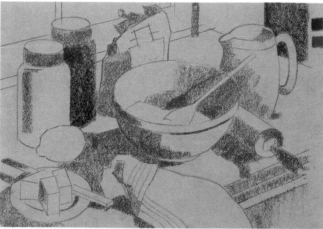

Stage 2

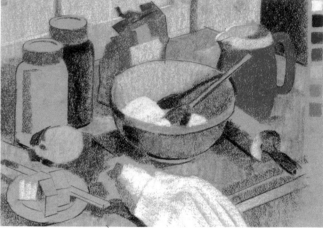

Stage 3

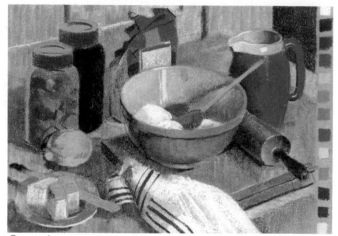

Stage 4

In the kitchen: demonstration

This still-life painting arose when I saw my wife busy in the kitchen one morning (but I rearranged it when I had the kitchen to myself!). It was, however, painted on the spot and not in the studio. (Do not forget the dust-sheet on the floor!)

Stage 1

I draw in the lines of the composition in charcoal on a buff paper, creating a division of the area into pleasing shapes. This helps the general balance while the lines themselves give direction and movement. This 'linear' composition is a sketching-in of the main structure of the picture.

Stage 2

The main addition here is tone, not too heavy at this stage, but notice how this enhances the composition and begins to establish a more solid and balanced appearance. I use a sepia pastel as being the best way to establish greater strength as soon as possible.

Stage 3

The light colour and white of the tea cloth are next introduced, together with suggestions of the actual local colour of the various objects. We now see, having placed the whites of the cloth and the flour, how strong is the tone of the buff ground. The sooner I recognise this the sooner I can adjust the general tones of the picture. The buff ground was chosen as being the most helpful in this particular instance and it becomes more apparent as the picture develops.

The local colour on the jug, lemon, mixing bowl etc. is only generally indicated at this stage but it gives a good idea of how the eventual picture will look.

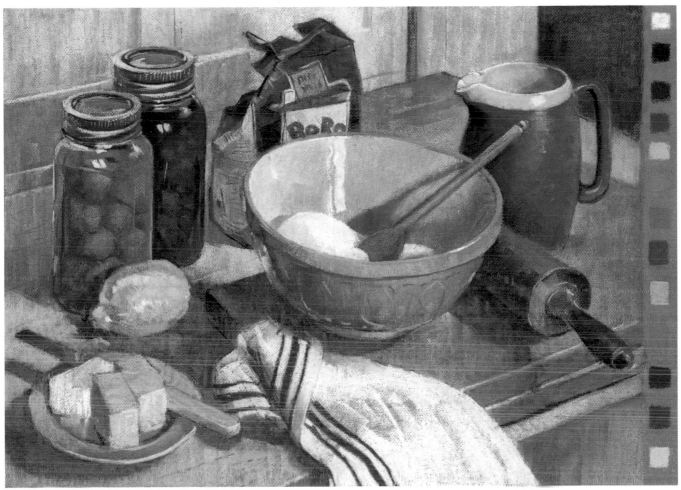

Stage 5 – the finished painting

Stage 4

More local colour is added with highlight accents at various points. I then work over the whole area bringing up to strength the half-tones and intermediate colours. This becomes a much easier process as I have already established the darkest darks and the lightest lights as minimum and maximum strengths.

Stage 5 – the finished painting

Much of the final painting concerns detail, and this has to be approached with restraint. It is not only tempting to smooth over the half-tones but tempting also to over-state the amount of detail included. A certain amount of drawing needs to be emphasised, and a little more careful rubbing with the finger to fuse various passages of colour will be necessary, as well as softening some edges and, lastly, adding the highlights.

If you have over-worked any part of the painting surface, brush it out with a hog-hair brush and start again. You cannot apply subtle drawing and fine detail on heavily applied pigment.

I have included a colour swatch with the finished picture as it progressed, having purposely omitted the tint names and numbers.

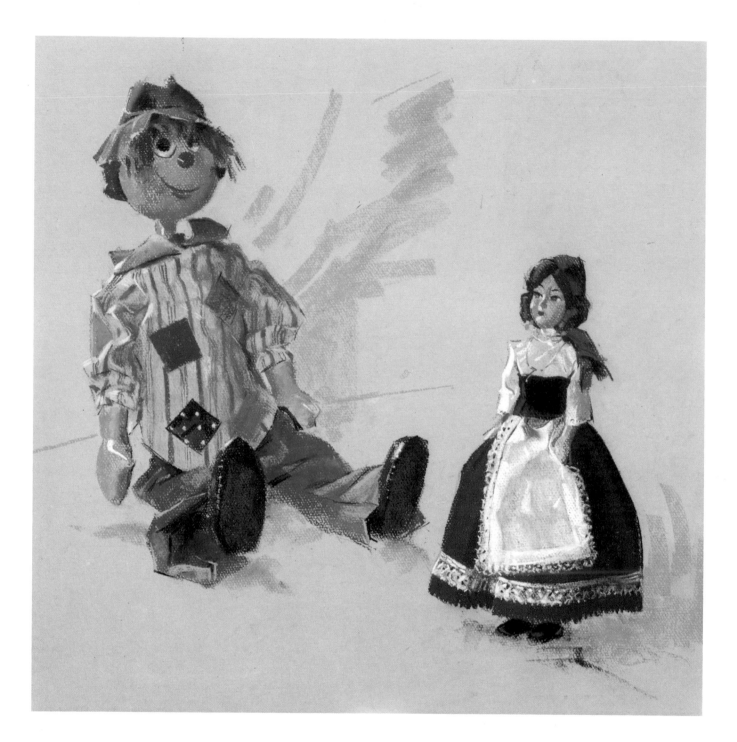

Children's toys

As subject-matter for still life, children's toys can be most exciting, for the simple colours and shapes offer many possibilities. Dolls, in particular, are excellent material, as are puppets. A friend of mine, many years ago, specialised in still life with puppets, for he found that they added drama to a still-life subject.

Toys are most effective for picture-making when they are found precisely as the children have left them, lying around in an untidy but spontaneous jumble. The examples shown on this page were borrowed from a neighbour with a young family. They in no way constitute a picture, for I merely drew them as individual items out of interest, and to show the variety of objects that might engage your interest when deciding what to look for in composing a still life.

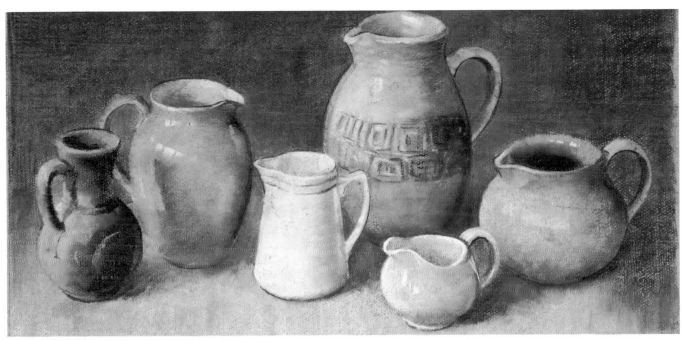

Tonal study illustrating the points made below.

Tone

We can obtain a better idea of tone if we paint in monochrome without any reference to colour. Just paint the tones or describe the forms – in fact, make a picture similar to a black and white photograph. Tone is a basic requirement in all painting, colour is merely an extension of this element. Together, they produce a complete interpretation of a subject. However, painting a good monochrome can be most satisfying in itself.

The introduction of colour must be made without upsetting the tone values already established. Also, do not forget that colours have their own individual and varied tone values. The similarity of tones in red and green colour-blindness test-cards causes the most confusion, because in them the tones are so similar in strength. However, if one of them is a very light green, and the other a very dark red, the difference is easily distinguished. This example (above) illustrates how the actual *tones* of colours can upset the balance of a monochrome painting unless we take great care. If two similar 'colour tone' objects are placed together, they seem to flatten or merge and their individual importance is affected. As far as the composition is concerned, they become, in weight, one object. Sometimes this is an advantage but we must intend it to be so.

Colour and interpreting it is mainly a matter of temperament; but all interpretations are subject to tone values.

Jug and fruit: demonstration

This painting is different in style to the previous examples and illustrates the point that there is no right or wrong way to apply the pastel.

I chose the dark blue-grey paper in order to make full use of this colour in the various objects composing the group. I made extensive use of it also in the background, in the tray, and within the shadows generally. It also gives me the necessary contrasting tone with which to obtain the brilliance of colour on the fruit.

Stage 1 (page 60)

I draw in the picture using white, but any light neutral colour would have suited just as well. The group is simple and I move it around until a satisfactory arrangement is achieved.

Stage 2

Having decided the general composition, I place a few strokes of colour around to emphasise the shapes and indicate the tonal values: these are only approximate.

Stage 3

As you see, all these strokes are made by the broadside of a piece of pastel and are not rubbed in. The only

Stage 1

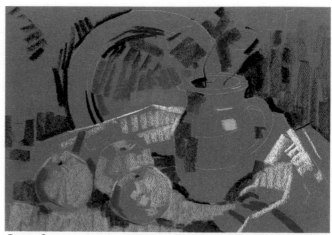
Stage 2

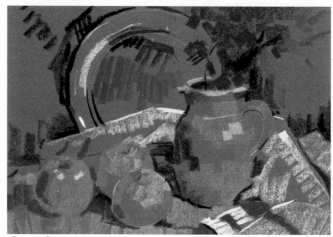
Stage 3

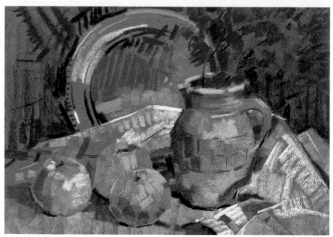
Stage 4

blending together of pigment is produced by the super-imposing of one colour on another, thereby obtaining the desired effect. This broad stylised technique has to be maintained throughout if continuity is to be preserved. Tempting though it is to rub with your finger or thumb – please do not.

Stage 4

Another factor is the firm direction of the strokes I use, which do not always follow the recognised form of the object. Sometimes the direction appears to be going 'against the grain' instead of with it. The general result is a patchwork of colours or mosaics. This can be seen clearly in the build-up to the final picture.

There is a certain vigour about this method of painting with pastel, but one must not get too stylised and sacrifice sound workmanship for technique – one of the pitfalls in the use of pastel which we all blunder into from time to time. But neither should experiment be discouraged, so try something a little different occasionally.

When using this treatment it is preferable to make short strokes only and vary the direction as much as possible.

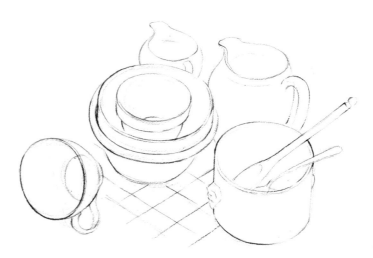

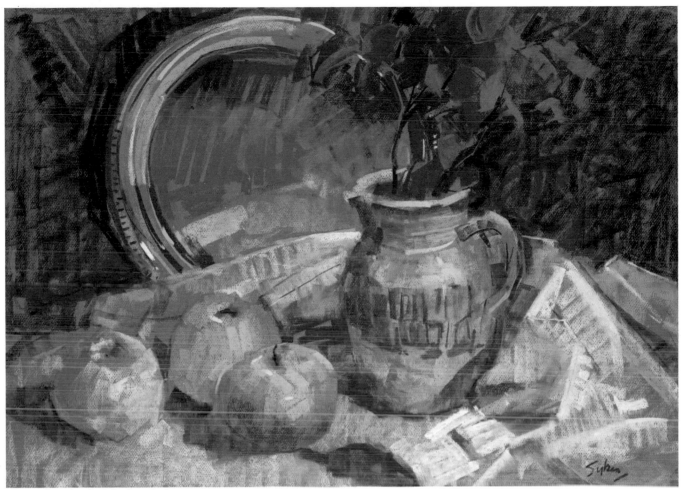

Stage 5 – the finished painting

Stage 5 – the finished painting

In the final painting I endeavour to minimise the exaggerated effect by cross-hatching with other strokes in a different direction, softening the overall appearance and making the final result more pleasing.

Where the background paper colour is used extensively in the design, great care must be exercised in the application of the pastel. Make sure that not all of the ground colour is eliminated, otherwise the effort of choosing a particular paper will have been wasted and the advantages lost. The paper colour will show through in the half-tones and darks where the pigment is not so heavy. Obviously where the colour requires extreme pressure, as in the highlights and lighter portions, none or very little of this ground will penetrate.

By experimenting you will learn a great deal about the use of pastel and eventually obtain a technique of your own. But one warning; do not aim at style. Painting techniques are a means to an end; when we become practised in the medium it is better to concentrate on the subject-matter – style will follow. Then your paintings will acquire their own particular individuality.

Roses: a preliminary sketch for a finished picture.

Drawing and observation

Drawing and observation constitute the foundation of an artist's training. It is not sufficient just to look at something: we must observe, analyse, then record by drawing. The one helps the other, the co-ordination between hand and eye being essential for good drawing or painting.

To draw, we have to analyse the subject in front of us. This in turn is impressed on our mind, which then motivates the hand to make the necessary strokes on the paper. Even a few lines in a sketch book can convey more to the artist and be remembered longer than numerous photographs. For, by drawing, we are forced to take notice and memorise. Drawing is also the discipline of painting; unless the hand and eye are drilled and co-ordinated, how can we record our impressions successfully?

There is no exclusive or right way to draw. Each person develops his or her own style. Every style is acceptable and each expresses the subject in a personal way. What is important is that the result be an honest rendering of the subject-matter and not just an effort to impress by dexterity or slickness.

Keep a sketch book handy and use it as often as possible; even making a few sketchy lines gets one into the habit of drawing. However, it is important from time to time to make more careful studies and to carry sketches beyond the brief statement to a more informed and detailed drawing. To become accustomed to the sketched impression limits the ability to progress and develop.

When drawing more than one object, consider the relationship between the various items chosen. Drawing a collection of items, as against single specimens, teaches us the rudiments of the all-important art of picture-making; in other words, composition. Give the group a limit by surrounding the items with a border, otherwise the tendency is to go on adding items *ad infinitum* until your composition becomes completely lost.

At times, however, I do add to a still-life group, even after beginning the actual picture, if the overall design seems to demand it. It is the final effect which matters.

Portraying flowers

Christopher Stones brings a very different (but equally valid) approach to painting flowers. Aubrey Sykes has shown you the basics of incorporating flowers into still life: Stones approaches flowers from a different view-point, one both subjective and objective. For him flowers are a subject for expressive picture-making – the actual names of the flowers he depicts do not matter, but his pictures are *about* flowers nonetheless. Between these extremes of both artists you will find what you yourself wish to portray.

Leaves – a tonal study on velour/flock paper.

Flowers: demonstration

Text and demonstrations by Christopher Stones

Painted on flock/velour paper

This is an interesting paper on which to work, which is used a great deal in Europe. It produces a sensuously soft image, and gives best results with the softest brands of pastel. Its advantages lie in the fact that it uses up the pastel very economically, and it encourages a very deft approach to painting, although it is difficult to erase mistakes. It is useful to have a good range of colours and tones because there is a limit to mixing on it.

Do not mix with your fingers on this paper, but work one colour in and put a firm stroke of another colour on top. Rubbing with the fingers does not help the colours to blend further. There is a pleasing subtlety and sensitivity in almost any work done on this paper, although it is less suitable for subjects where a very sharply defined image is intended.

When using flock paper, try not to fill the surface of the paper too soon. If you do so, it quickly becomes clogged, and you may have to brush some out with a dry, clean oil painting brush. It is better if you build up gradually to the required density of pastel layer as you become more decided about the exact forms that you want.

Stage 1 (page 64)

Having done a tone study to decide on the composition I wanted my first stage to establish the basic positions of the flowerheads, ignoring the actual spiky character of each head but trying to determine the different directions they were facing, and to make sure that there was enough variety of size and colour variation. The flowers were growing naturally, and I wanted to catch the informality of the shapes that they made by using some that were turning away from me and suggesting some distant blooms.

Stage 2 (page 64)

Next, using the flat edge of the pastel sticks, I lightly block in the darks in the background in order to describe the contours of the light flowers. I use light strokes so as not to overload the paper with colour and to allow me to add more colours later. I use deep green in the lower part of the picture and a blue-grey higher up. This begins to suggest distance and volume.

Stage 1

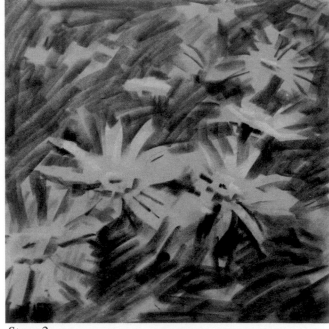

Stage 2

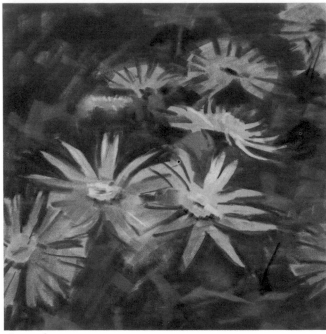

Stage 3

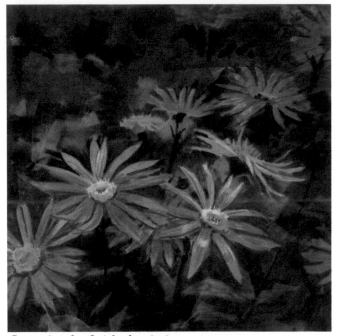

Stage 4 – the finished painting

Stage 3

I continue to sharpen the image by filling in the background more solidly with the beginning of leaf shapes. Light areas on the selected flowerheads is stressed and the other flowers darkened. I develop the modelling more clearly, particularly in the centre of interest.

Stage 4 – the finished painting

I check the relative importance of individual flowers so that the less important blooms do not vie for attention. I then decide on just how much modelling I want in the foliage in the foreground and accent it accordingly.

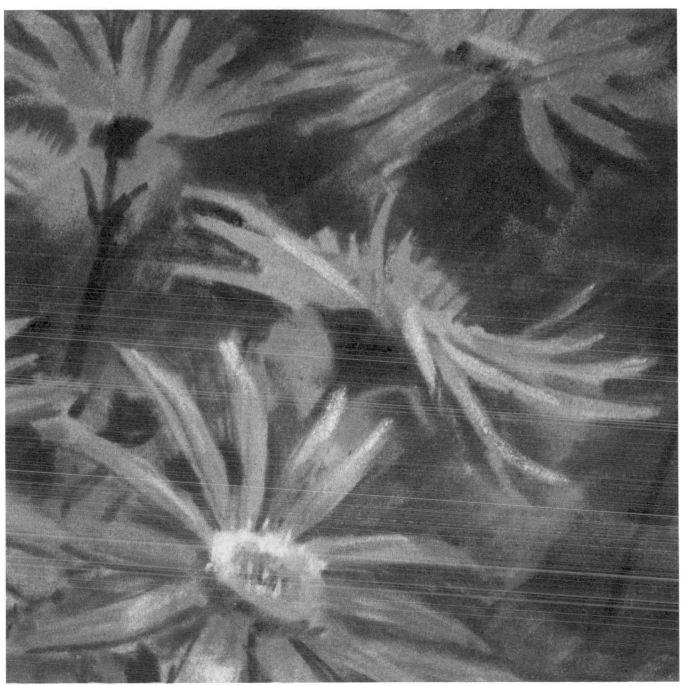

Detail (actual size)

Detail (actual size)

Only now do I really clarify the image fully in the centre-right portion of the picture. Most of the work of forming detail is done with the ends of the pastel sticks. The paper will not accept any very great detail of modelling.

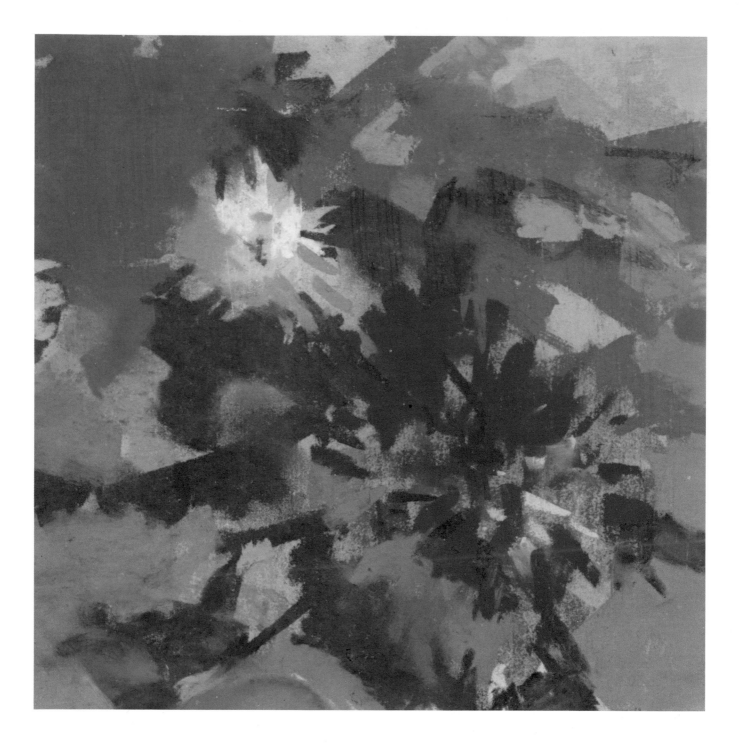

Flower heads and foliage

Another flower study by Christopher Stones. Almost abstract, the flower shapes are merely suggested (again, one does not know what kind of flowers they might be). The study is held together by the contrast between the strident warm colours of the flower head and the cool colour tones of the foliage and background. An extreme form of flower depiction, but effective. This example is done on sand-grained paper.

Notice how the choice of a dark grey Canson paper brings out both the tonal values of the rose petals and the dark shapes of the vessels and the shadows. In this sketch he uses only two pastel colours – black and white. 'The paper,' he says, 'makes the rest of the sketch work for me.'

INTERIORS, BUILDINGS AND TOWNS

by Christopher Stones and Aubrey Sykes

Text and demonstrations by Christopher Stones

Just as a writer is often at his best when he is describing what he has experienced, so it is with the painter. I always tell my students to open their eyes to the array of subjects all around them, at their place of work, in the home, or in the city, town or village where they live.

The pastel medium can be used for a very wide range of subject-matter, and it can produce all the effects of texture and solidity that you will need in painting buildings, whether you approach them in an atmospheric style, simplifying the forms, or if you seek immense clarity of image and detail.

I have included different approaches and techniques to the subjects in this chapter, but all are using soft pastel, not one of the varieties of oil pastel or wax crayon available on the market. I have used different papers and show their applications to the varying subject-matter.

I start with an introduction to the rules of perspective as they govern the drawing and painting of buildings and interiors. These rules do not require artistic talent; they can be learned by anyone, and will help to make your pictures convincing. You will see in the demonstrations that follow how and when I applied them.

Perspective

The following are some of the basic principles of perspective which are useful to the painter; and they are illustrated on the following two pages.

Figure 1 (page 68)

Stand in your room looking towards the corner furthest from you. Consider the ceiling and floor lines of the white left-hand wall, (outlined in blue). If those two lines (in blue) were extended to the right they join at a blue cross. Similarly the blue right-hand wall has ceiling and floor lines which extend to the left, meeting at another blue cross. These blue crosses are called vanishing points. Both vanishing points are on the same level, which is your eye level. If you now sit down, you bring the eye level

London chimney pots

down, and all the angles of the floor and ceiling lines change in sympathy. The new vanishing points are the white crosses, and the new positions of the ceiling and floor lines are outlined in white.

Figure 2 (page 68)

Now look towards the farthest wall of the room, still in your sitting position. Both the side walls (shown in blue) have ceiling and floor lines which meet at a single blue cross. Stand up again and these lines change and meet at the white cross. Remember that this only happens if the two blue walls are built exactly parallel. In an old house like mine there is no right-angled corner anywhere, so no two walls have quite the same vanishing point!

Figure 3 (page 68)

Here we are in a perfectly straight street, which is almost entirely governed by a single vanishing point (another blue cross). Notice how many things are controlled by it: the white fronts of the buildings, even when they vary in height; the doors and windows, the pavement, and even the white line markings in the road.

Figure 4 (page 69)

Seen from further away, or obliquely, a building often has just two vanishing points and these are on your eye level. Here all the faces of the building coloured red are built

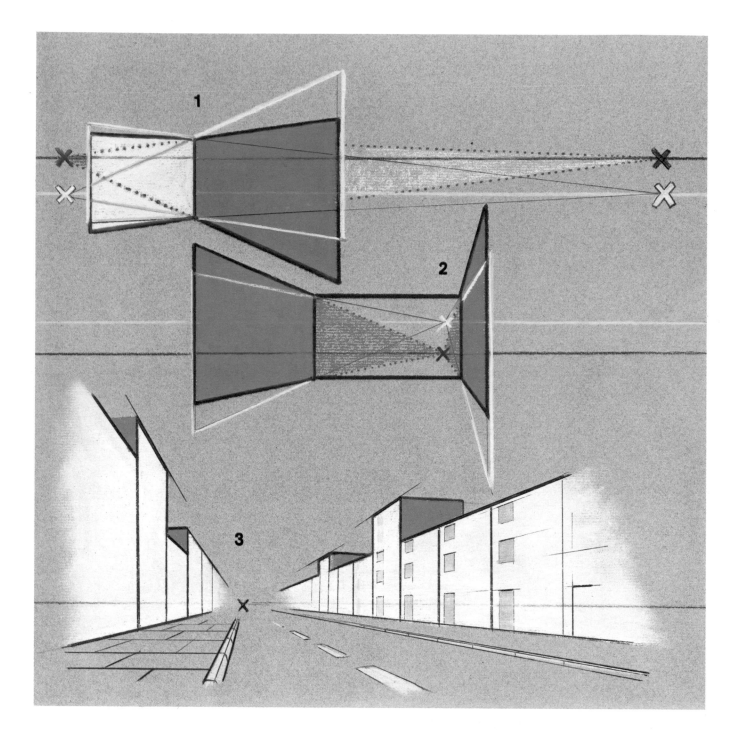

Figure 5 (page 69)

parallel, and thus are all governed by the red vanishing point. The faces of the building coloured yellow are built parallel, and are governed by the yellow vanishing point. The roof ridges and any tile patterns will also be in sympathy with the vanishing points shown, but being pitched roofs the slopes do not obey.

If you have to make house fronts of similar width pan away in perspective, this can easily be constructed. The same goes for fence posts, or any other regular features (e.g. lamp posts). Having decided on the height of the first upright, establish the distance between it and the second. Find the vanishing point on your eye line, so that you have an upper and lower line for your fence, house-fronts etc. Now take a line from the top of the first post through the point exactly half way up the second and, where it meets the base line, you plant

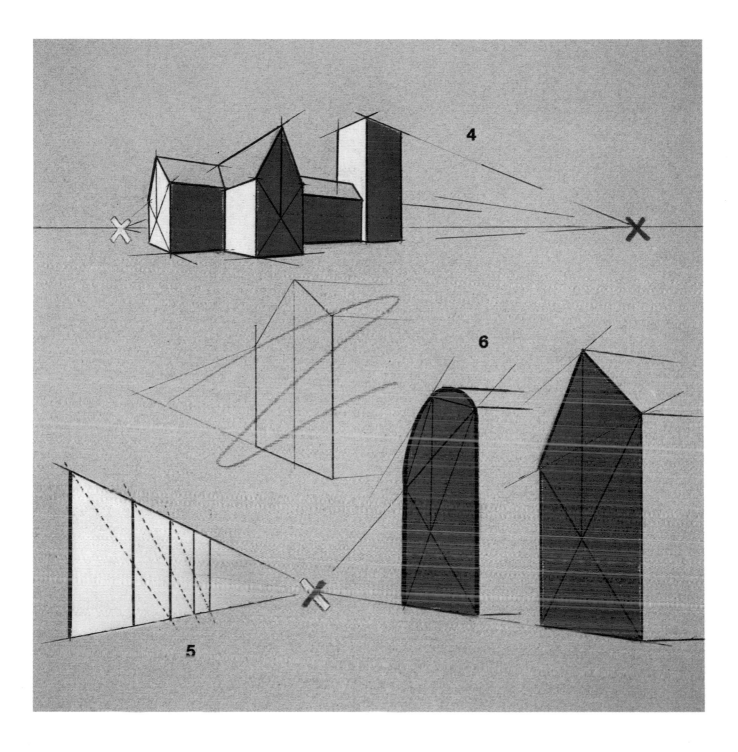

your third upright. Similarly, take a line from the top of the second upright through the centre point of the third, and where it meets the base line you plant your fourth upright.

Figure 6 (above)

The same principle applies when finding the centre of an arch or a pitched roof. First, find the *actual* centre of the red wall or opening; this must be done by plotting the diagonals and, where they cross, is the centre of the wall. Take an upright from there and you have the top of the arch or the point of the pitched roof. Do not just measure the halfway point with a ruler – for the nearer half will obviously appear larger, not the same size.

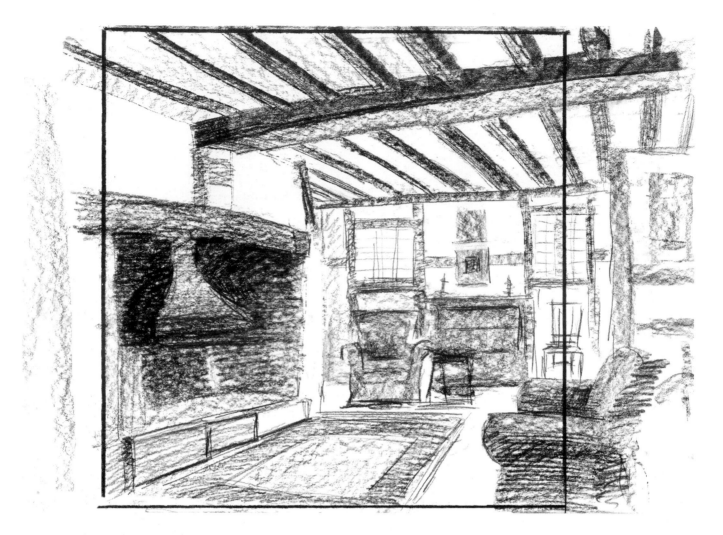

The layout (above)

In this particular painting it was necessary to plan the composition very carefully because there are so many strident shapes and lines. In the ceiling area there are the wood joists slotted into the large centre beam; the walls are of timberframe construction (and therefore a mass of rectangles); the inglenook fireplace is a powerful dark mass; and on the floor the oriental rug emphasises the lines of perspective. The layout plan, which is drawn in black pastel on cartridge paper, helps me to balance the opposing angles.

Cottage interior: demonstration

Do try to get into control of lighting, as you must in painting an interior; when you have mastered this aspect, you will find it of enormous help when you return to outdoor subjects. You become much more aware of the source of light for your painting. Just look up from your book towards a window or other light source, and screw up your eyes so that you can only just see. You will notice that the light source is the only thing that you can see. Now gradually open them and, one by one, other things become visible; in the order of the level of light on them the most brightly lit appear first and the more dimly lit later. You will need to keep this order of highlighting and contrast when you paint a subject like this.

Because I live in a seventeenth century cottage with polished oak beams, I have chosen this subject for an interior, but you will find any number of possibilities all around your home. Remember, however, to protect your floors and carpets by covering them with a dust-sheet or piece of polythene before you start.

Stage 1

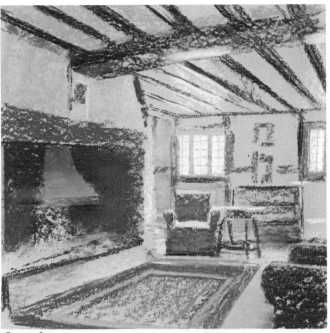

Stage 2

Detail

Stage 1

I first lightly block in the areas of light and dark. I chose to paint on my favourite '00 Grade' woodworking sand-paper because I want to make very sharply defined shapes in places, and also because it is easier to blend colours on it so that one melts into another (as will be seen in the Detail). I keep it all very sketchy at the beginning, deliberately preventing myself from starting on small details.

Stage 2

Gradually, I begin defining the shapes and filling the grain of the paper. I lay one colour on another and when sufficient pastel is on the paper I mix it together with my fingers by rubbing lightly, in order to achieve subtle gradation of tone and colour. If you do a lot of rubbing and adding of further colours to modify them, do re-define the shape from time to time. This type of pastel painting can easily become fluffy or woolly if you do not guard the sharpness of edge jealously.

Detail (see finished painting on page 72)

The ceiling timbers are of secondary interest in this painting, although I want to have them sharply defined. Now, just because they are not fluffy-edged one's attention is not automatically drawn to them. I have dark-ened the light sections between the joists so that the *contrast* between them and the joists is not too great. It is the contrast of light against dark that attracts undue attention; keep this contrast down and, however sharp the edges, the area will not stand out.

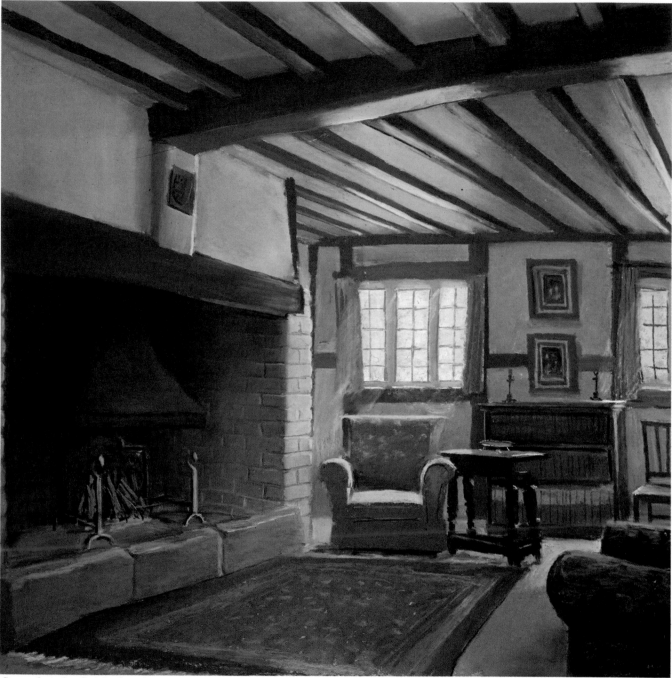

Stage 3 – the finished painting

Stage 3 – the finished painting

The final stage is to look at the textures of individual areas. I accent the slight hint of pattern on the chair covers, and keep the painted plasterwork smooth in comparison with the surface of the rug (which I did not touch with my fingers) and which has thus retained a woven, tufted appearance. I defined the sharp lights on the farther green chair, on the oak joint-stool and on the bookcase, as well as on the carpet near them. These strong staccato accents attract attention and form the centre of interest.

72

Viewpoints

You will have noticed in the previous demonstration how the artist has, by skilful use of the perspective lines in his composition, drawn the eye to the focal point: the area between the two windows. If he had positioned himself in the centre of the room his viewpoint would have given him a much less satisfactory picture. Remember that your first viewpoint of your subject may not be the best. Prowl around your subject, try sitting down, standing up, look at it from as many angles as you can, making linear and tonal sketches of what you see. Then, when you have made several quick studies you can compare them and choose which viewpoint will provide the most satisfactory composition.

We have to cultivate a 'seeing eye' by learning what to look for and this can only be achieved by practice. The trained eye is always looking for interesting and unusual viewpoints and comparing them with others. Carrying a sketchbook and making notes of your observations is the best way of remembering what you have observed. The two pictures on this page illustrate how Christopher Stones has deliberately chosen each viewpoint to bring out the dramatic and intimate qualities of his subjects. In the painting of the ruins of Fountains Abbey he selects a viewpoint which allows the sky shape contained within the foreground arch to dramatise the ruins beyond. In his study of Sir Christopher Wren's house he sat on a raised wall opposite so that his eye line was level with the top of the door, thus exaggerating the perspective lines at street level and upper windows.

Editor

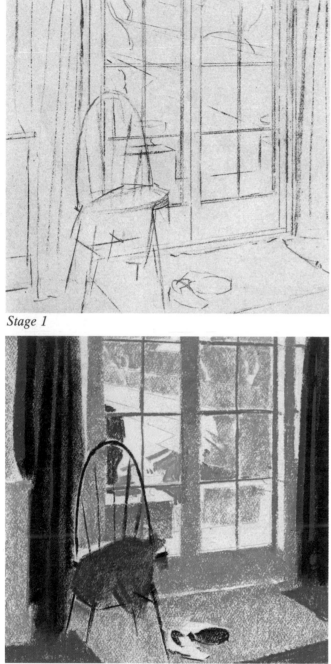

Stage 1

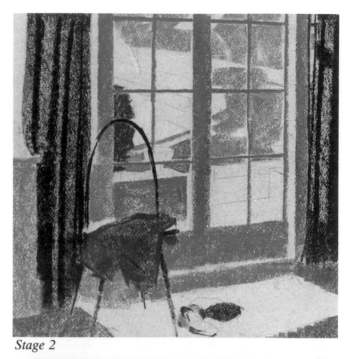

Stage 2

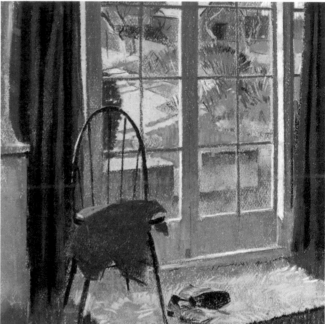

Stage 3

Stage 4

Interior: demonstration

Text and demonstrations by Aubrey Sykes

Stage 1

I draw in the outlines with charcoal, making sure that there is a possible composition and that I have included the main points of interest which first attracted me to the subject.

Stage 2

This stage is supplemented by the careful addition of darks and half-tones – a tonal sketch, in fact.

Stage 3

The main light in the picture appears on the curtains, the glazing bars of the window, and on the lawn seen through the window. I have tried to keep the lawn the principal light area: this means that the others have to be modified to some extent.

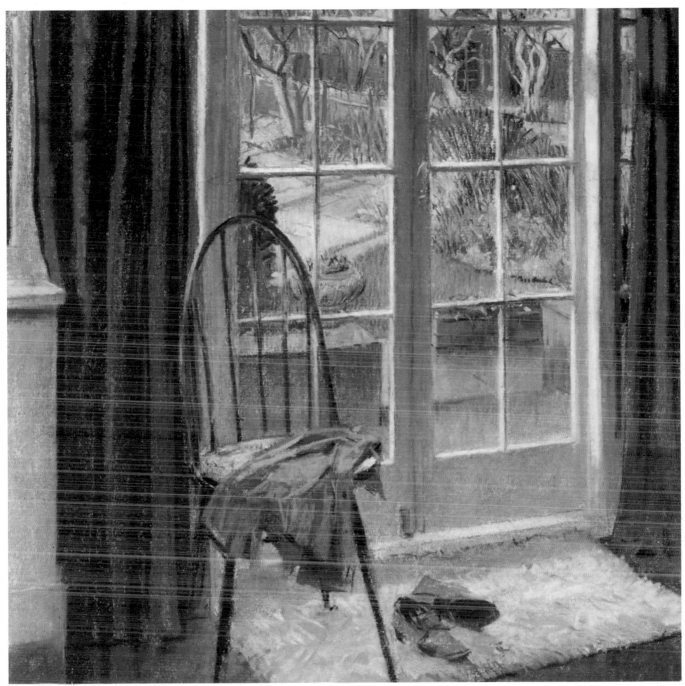

Stage 5 – the finished painting

Stage 4

Placing the dark tone of the bush against the light on the lawn is helpful, but further toning down of the glazing bars is necessary to give recession through the window to the garden beyond. Introducing detail proves difficult, for the temptation to over-subscribe could lead to a loss of unity over the whole picture. Detail we must have, but it must not be too assertive.

Stage 5 – the finished painting

With the final drawing-in, I use a fairly sharp edge on the pastel for the finer lines and detail. This can be obtained by using the edge of a broken stick of colour or by fining down an existing piece by rubbing it on a rough paper. If a large amount of your pastel stick has to be removed, use a sheet of glass paper, then finish off with rough paper.

Many of the darker areas and items I now adjust by introducing a slightly different colour to provide variety, to relieve the monotony of the darks, and produce a more acceptable colour harmony.

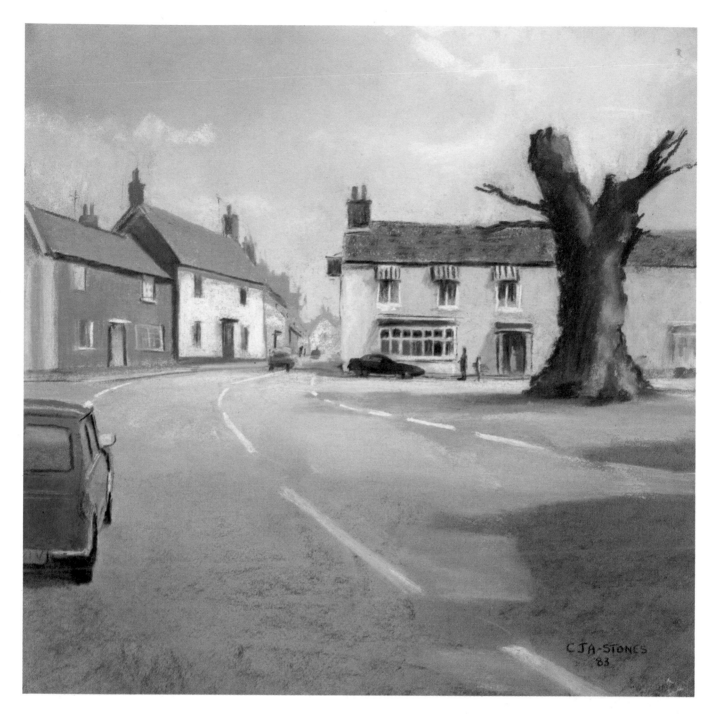

Weather conditions — change of mood

Text and demonstrations by Christopher Stones

What a difference the weather and lighting make to a subject! I have chosen a street scene from Ramsbury, the village in which I live, and have taken two quite different days, one in sunshine and the other after heavy rain. The layout is identical but the moods different.

In this 'sunshine' version of the painting my interest is in the building on the right behind the stricken elm tree. The features of the windows and doorway stand out dark and clearly defined against the pink building. The dark of the tree and the sports car, also clearly defined, help to make this area the one of greatest tonal contrast in the painting, The small van on the left I deliberately underplayed, so that it does not fight for attention. Note the simplicity of the sky and roadway which I felt was necessary to counteract the busy area of the buildings. I like the faint shadows cast on the road by buildings out of sight on my extreme right. They help to enclose the light beyond, and thus enhance it.

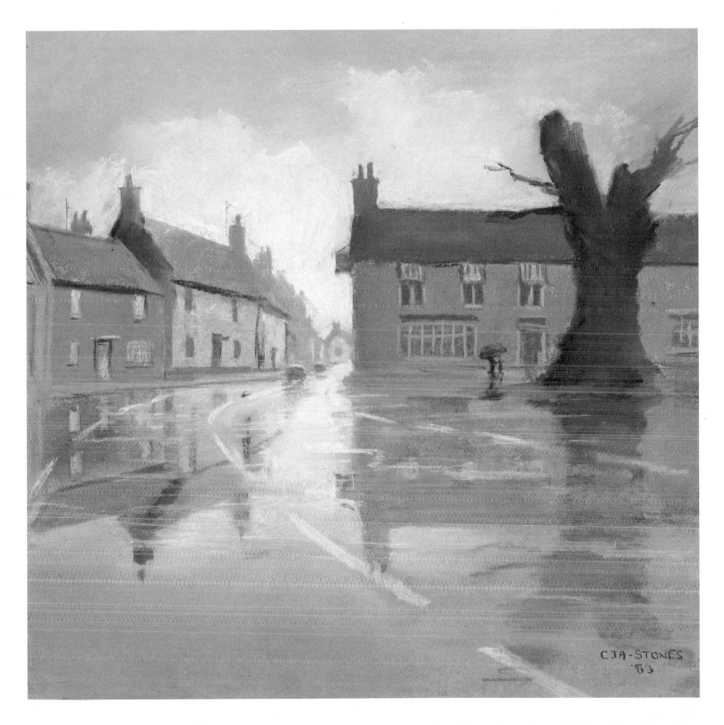

I love the effect of wet roads and reflections in them and make a positive feature of these in this version of the composition. Notice that the light is coming from far in the distance, which means that the eye is drawn right down the narrow street. The light is now not on the façades of the buildings, so much of the detail and contrast has gone. Even the dark of the tree against the pink building is not in sharp enough contrast to hold

our attention. In both versions of this subject the white markings of the road almost act as lines of perspective, drawing you into the subject, but here they are vitally important in holding on to the fact that this is a road, not a river.

If you get a few rain-spots on your painting, as I did, do not worry! Let them dry out completely, then touch them lightly with your finger and they will disappear.

Power station: demonstration

Layout

In the layout drawing (above) I have taken the whole sweep of landscape, emphasising the flatness of the land and the expanse of open space, with the distant hills just visible. Of this panorama I chose the section shown by the heavy black rectangle. It is important to retain a large area of sky, so that the road in the foreground does not take up too much of the painting, and I want to emphasise the zigzag of road to lead the eye to the power station, but not to hold attention in its own right. It is usually advisable to avoid putting the horizon line exactly halfway across the painting; also avoid placing the principal object in the bull's-eye position in the middle as the result is often dull to look at – but here I have almost done both! Although the horizon line is halfway up the painting it is very restrained, and a more strident division is that between the rich dark greens of the foreground and the pale restrained greens of the distance

The sweep of the road is a dominant feature in the structure of the painting, and it is possible that its continuation on the left in the middle distance could take the eye out of the picture. However, just before the road disappears out of sight there is another bridge on

the extreme left of the painting, and the road it carries leads us to the power station, which focuses attention upon it.

A road or river coming to the bottom of the painting can be a lead-in or a lead-out. The first is needed – the second disastrous! However, the eye tends to be attracted to light, as well as to contrasts; so to have dark tones close to us, getting lighter as the landscape recedes, and the sharp definition of the first bridge, all helps to lead the eye *in* rather than *out* of the picture.

Stage 1 (page 79)

Using grey Canson paper (smooth side) I start lightly, using broken sticks of pastel on their sides, to record the main darks and lights. Once again, by almost closing my eyes I can see the dominant lights and darks in the subject. I press extremely lightly at first, hardly putting any pastel on the paper, yet starting to place the dark sides of the cooling towers, the shape of light vapour rising from them and some of the darker features of the foreground. I also begin to define the horizon line. At first I use a darkish grey and white pastel.

Stage 1

Stage 2

Stage 3

Stage 4

Stage 2

Next I search for the basic colour layout, still not allowing myself to see any detail, to create the colour mood of the painting. It is better not to press too hard and fill the pores of the paper at this stage, because then you can modify the colours and make changes more easily if you are not pleased with a particular colour relationship. Pastel can be lifted off the paper with a piece of 'Blu-tack', which you would be advised to have in your hands all the time you are working to keep your hands clean. The point of not filling the paper pores is especially important when one is using a paper like this, which has a limited capacity to hold pastel. If you overload it it will take no more pastel.

Stage 3

This is the stage at which I begin to work pastel into the paper with my fingers, having decided that I am satisfied with the colour relationship. Working the pastel in with the fingers produces a very misty effect, starting to create the volume and recession in the painting. I found that I had to rub in various colours and tones to achieve the gradation in the sky. I make sure that the dark greens in the foreground are rich and contain enough of an orange hue to bring them forward, and the distant colours are pale and progressively blue with distance. I then put the light sandy colour on the cooling towers.

Stage 4

Having arrived at a rather blurred statement, I concentrate next on defining the shapes, to record the edges of fields, trees, hedges and some of the houses. I press quite hard with the sticks of pastel, occasionally using the end or a corner of a stick of pastel to record a small object, but mostly I still use the side. Next, I turn my attention to the road and the nearest bridge, gradually defining the shapes, postioning the cars and lorries, but allowing nothing to be more than a suggested form – no real detail in the traffic. I also decide that it would be unwise to position any vehicles too close, as they could tend to dominate: their principal function is to lend scale to the whole painting.

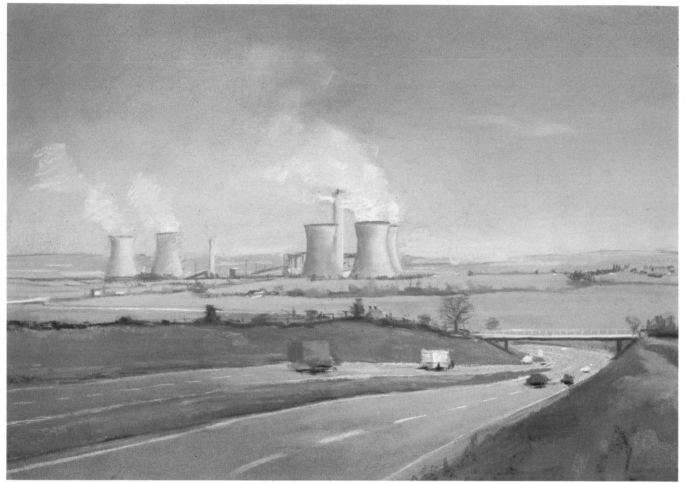

Stage 5 – the finished painting

Stage 5 – the finished painting

I finally toughen up the drawing of shapes. Note that I try to resist finishing any part of the painting until now, so that the whole reaches its conclusion together. Some people start at the top and work downwards, finishing as they go, so that at half-time the top half of the painting is complete. I personally find this an impossible way to work because everything in the painting relates to other things in other parts of the picture: the echo of a colour, the use of one colour to enhance another, all these things need careful adjustment in relation to each other, and I find this is infinitely easier to do if the painting has grown overall.

I want to enhance the greenness of the fields, so notice the small accents of red I use here and there, a house roof, the red car, the pink of a distant town on the right. If you want to draw attention to any colour, put a speck of its spectrum opposite nearby – here red is the opposite of green. However, should you wish to take the acid quality out of a green that seems to shout at you, put in a touch of red again, (the opposite spectrum) and mix it in thoroughly. This will neutralise its sharpness. Learn about the colour spectrum. This principle can be used for all colours.

Figures with buildings

A street scene looks very empty and unnatural without people. Also, figures are extremely useful for establishing the scale of the surrounding objects and they are useful too in a landscape, where there may be no other key to the size of trees. In buildings there generally are some existing clues, such as the height of doorways, sizes of windows. In the painting of the power station on page 80 the motor cars help enormously in establishing the size of the cooling towers, as the few people do for the buildings in the village scene on pages 76 and 77, and the rudimentary figures in the abbey ruins on page 73.

Houses of Parliament, London: demonstration

I chose this subject particularly because of the simplification needed in tackling it. It is a less usual aspect of the Palace of Westminster, with the clock tower of Big Ben visible beyond the main body of the building.

I painted it on the rough side of dark grey mi-teintes Canson paper, one of the papers most commonly used by pastellists. It has a pronounced cellular texture on this side, which is visible when you drag a one-inch piece of pastel lightly over the surface. I do not want to portray every piece of carved neo-gothic tracery, but to give the overall impression of the scene. In fact my interest was much taken by the light in the sky beyond the clock tower, which has lost most of its detail in a lovely bluish grey silhouette.

Tonal study (page 82)

I first look at the subject with half-closed eyes, so that I can see the general layout of darks and lights within my rectangle. The building seems to go on for ever, so I have to decide which part of it really interests me. It is important to make a tonal study rather than going straight into the painting; by so doing I can see whether the layout really is going to work.

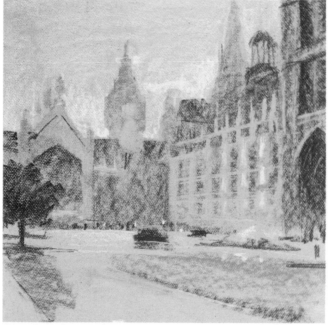

Tonal study

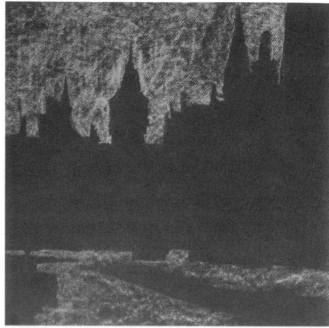

Stage 1

Stage 2

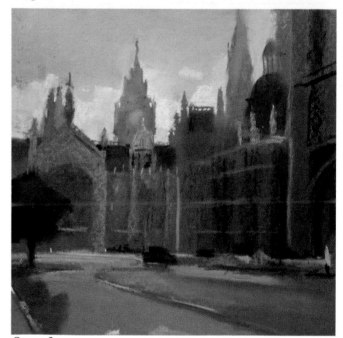

Stage 3

Stages 1–2

Having decided that I like the general layout, I start on grey Canson paper, chosen because I want some of its colour to show through. My first strokes with the side of a one-inch piece of palest blue pastel are to block in the light sky in order to find the dark silhouette of the building, and the light on the wet tarmac.

Next I start blocking in the dark areas of roof, the tree on the left, the dark under the arch on the right, and the odd touches of dark of the London taxis. I try to put everything down in a generalised way, without

falling into the trap of getting involved in detail in any one place. This demands self-control because one longs to get at the detail! But try to let a painting grow as you gradually open your eyes and progressively see more.

Stage 3

Here I add the basic modelling of the stonework, where possible suggesting the form. The left half of the façade I hardly work on at all. I work much more pastel into the sky, and smooth it in with my fingers, the same with

82

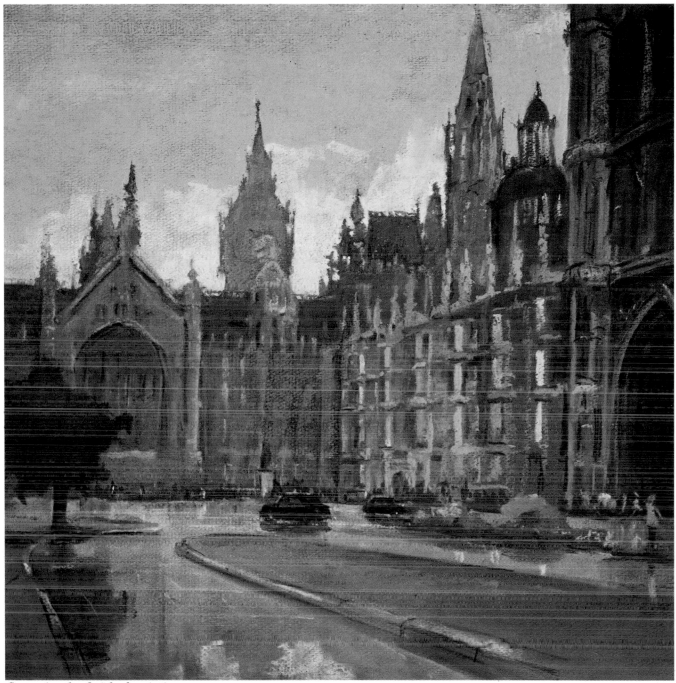

Stage 4 – the finished painting

the roadway and grassed areas. This gives a greater contrast with the building, and relief from the pattern of small shapes.

Stage 4 – the finished painting

With a subject like this it is vital not to let oneself be carried away with recording every rib and pinnacle of gothic tracery. I want only to suggest the structure in the left half of the building, although introducing a little warmth into the stonework. On the right I describe the

lightness of the tracery and especially the way the windows catch the light differently. In the foreground I decide to make the most of the wet glow on the road and some of the sparkle of reflection. I also especially want the hint of red in the throng of people in the distance. These are put in as flecks of colour rather than as individuals with heads, bodies, arms and legs. (See Figures, page 81.)

Street furniture

I have often been shown paintings in which all the signposts, lamps, postboxes, and other features of a street scene have been left out. I wonder occasionally why such artists have not completed the operation by putting the clock back and painting in horse-drawn carriages and figures in crinolines and frock-coats!

Street furniture is an integral part of today's townscape, and can make wonderful shapes and splashes of colour in a painting if used constructively. Roadmarkings, for example, can be invaluable in a composition (see page 77), and the silhouetted shape of a streetlamp against the sky can be a very striking motif.

If a particular lamp, post box or telegraph wire is in a unfortunate position its impact can easily be lessened merely by modifying its tone and so making it almost unnoticed. Legible street signs, such as street names, and instructions to stop, turn left or turn right, can occasionally distract, because our eyes are conditioned to leap to the written word, and the writing may attract more than its due attention. To remedy this it can be slightly disguised, so that it is legible only with difficulty, or the space can be filled with cyphers that look like lettering but are illegible. I rather like legible lettering in paintings if it is used in an interesting way and find the international roadsigns are particularly effective.

'No entry': demonstration

I have often considered producing a painting in which a roadsign was the star turn. Usually my main interest in a street is in the reflections in a window or part of a motor car, but here this bossy 'No entry' sign at the edge of a pedestrian precinct was the principal attraction. It was so pert and dictatorial against the clean-cut shapes of the office-block behind. At first I thought of placing the roadsign centrally, but somehow I could find no arrangement of shapes around the sign that seemed comfortable. Eventually I decided on the tonal study (page 85), which pushed the main substance of the painting up into the top half of the square, leaving the lower half almost clear, except for a very useful pavement edge and accompanying yellow 'no parking' line.

Stage 1 (page 85)

Following these decisions I start on the actual paper (00 Grade sandpaper), placing the dark windows, the dark side of the roadsign post, the edge of the pavement, and of course the red disc. All of these are blocked in with the side of the pastel with only light pressure, in case I need to move the shapes slightly.

Stage 2

The next step is a continuation of the same process, to establish the general colour layout, by pressing slightly harder on the pastel to leave more pigment on the paper as I become more confident of the positions of objects and their required emphasis. The light on the corner of the building attracts me greatly. At this stage I can look at the painting with half-closed eyes and visualise how it is going to turn out.

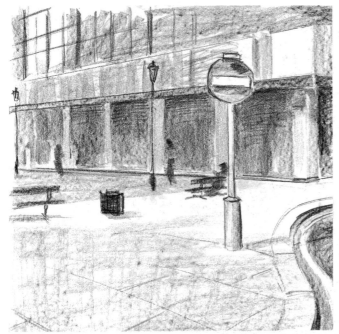

Tonal study

Stage 1

Stage 2

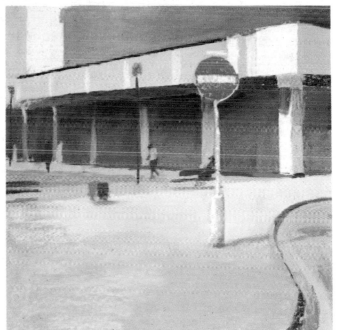

Stage 3

Stage 3

I now fill pastel into the pores of the paper, and smooth it in with my fingers. I treat this much in the way that a watercolourist may lay down a general wash in an area, so that when it is dry he can draw in with a small brush the detail required. There may be a granular texture to put onto my rubbed-in areas of pastel, there may be figures to place over the top. At this stage I ignore the layout of paving and the shapes of the windows above, and concentrate instead on the reflected image as flat areas of tone. At this stage too the positions of the figures, benches and lamp posts are roughly established. Note that it is useful to place a light figure against a dark background and vice versa.

See overleaf for the finished painting.

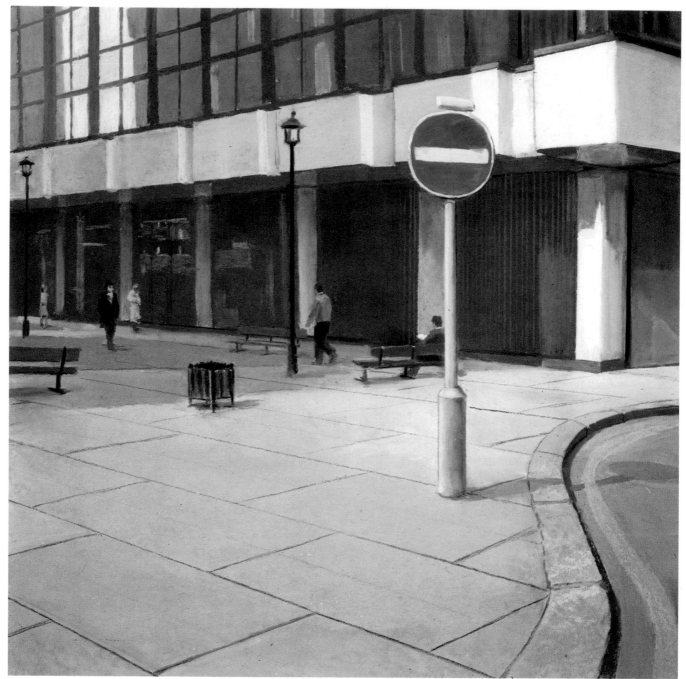

Stage 4 – the finished painting

Stage 4 – the finished painting

Here I define all the required sharpness. It was necessary to get out the perspective string again (see page 67) so that the upper windows and the paving are properly aligned. If you want a really straight line do not be frightened of using a ruler. If you need to make a block of colour come to a really abrupt stop with a straight edge, place a piece of tracing paper over the painting to mask the adjacent shapes. Work in the colour onto paper and masking sheet with your fingers and lift the tracing paper away. There is your perfect edge! But do not use this method unless you really want the ultimate in sharpness, because it can look too mechanical. Sometimes in showing brickwork I will deliberately plot it too precisely first and then smudge the perfect image until it has just the amount of detail needed.

At this final stage of a painting I sometimes use pastel pencils, which can be sharpened to a point like any graphite pencil. However, I try not to get carried away with unnecessary detail.

PORTRAITS AND PEOPLE

by Dennis Frost

Unlike other subjects in painting, portraits and people have an extra dimension: your sitters are not only subjects but *partners* in a shared activity. They know what you are doing, and will almost certainly want to see your results. They also know what they look like, and compare your work silently to themselves or openly to you with their own image of themselves. This fact presents one of the many challenges of portraiture – and can make it one of the most rewarding. If you want to try portraits and people but are unsure how to tackle this psychological factor, there is always one model to hand who can keep secrets – yourself. Set up a mirror and go to work!

Look at your face and analyse it – what is its general shape – long and narrow, or round? Study your hair – does it frame your face or partially hide it? Look at your features carefully – see how they fit into your skull or clothe its surface with flesh. Once you have mastered the analysis of your own face by making several sketches of it, compare them critically with what you see in the mirror. You will begin to understand the relationship between artist and sitter, and learn something too about the partnership which is a prerequisite for painting portraits and people.

Posing your model

Posing for a portrait can be tedious. Although the model should be prepared to sit for a stated time, frequent rest periods must be given. An interesting radio programme, or favourite taped music, will often relax and entertain your sitter. When the model is a child, a visual stimulus, such as a bowl of goldfish, or a caged bird will often hold their attention, leaving the artist free to concentrate on painting the picture.

When the preliminary negotiations regarding the number of sittings, the costume and the setting are completed, the first sitting can be started. During a sitting I like the conversation between us to flow for short periods; this way the sitter presents a variety of expressions without being aware of doing so, and one can observe how the shapes in the face alter, say, during animation and amusement, and so suggest not only the most appropriate physical picture to capture, but also the mood that motivates it.

Personally, I have an aversion to painting a broadly smiling or laughing portrait. It is all but impossible for the sitter to retain that sort of expression for the duration of a sitting and the strain involved becomes transmitted to me as the painter and the picture will suffer.

A smile completely alters the shape of a face. The eyes narrow, the cheeks widen and the distance between the top lip and nose shortens; humour, therefore, is not only conveyed by the shape of the mouth but also through muscular changes in the face and sometimes in the whole posture.

The preliminary sketch for the portrait is very important. If the shapes have been drawn accurately one can move on to colour and tone with confidence, but the drawing *must* be correct. To make sure, look at your picture through a hand mirror, for the reverse image will help to pinpoint any obvious faults.

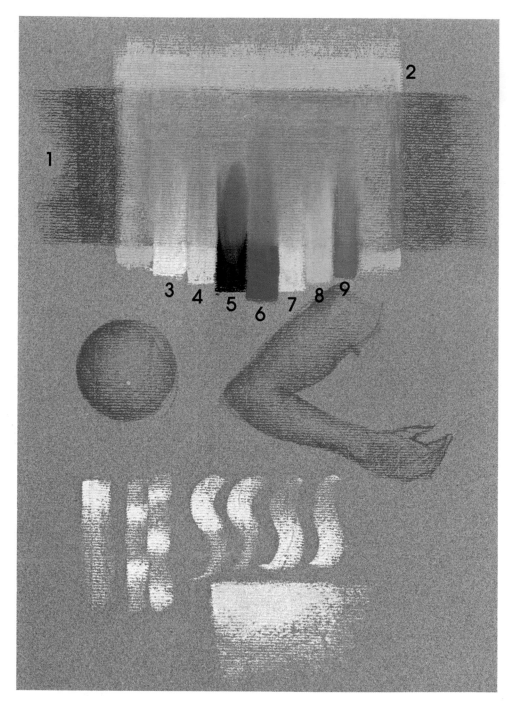

Flesh tones

I use these nine colours for all my portraits. I make the basic flesh tone by superimposing madder brown O over sanguine conté (colour 2 over colour 1). I use the other colours to indicate flesh under varying conditions of light and shadow.

1 sanguine conté
2 madder brown O
3 silver white
4 Naples yellow 2
5 Vandyke brown 8
6 poppy red 6
7 lizard green 3
8 Prussian blue 1
9 blue grey 4

I drew the arm and ball with a short piece of sanguine conté used on its side. I indicated the form by varying the pressure of the stroke. The white strokes below show the extreme changes of tone achieved by the slightest variation of stroke pressure. If you are a beginner, practise this until you begin to develop a 'feel' for pastel.

Application

Pastel can produce very subtle tones or colours, though it has an earthy quality; it has a wonderful fluidity, yet each stroke, whether quick or slow, has permanence and weight. Above all, pastel can give rhythm and a special vibrancy of colour.

Pastel has to be used with care and skill if you want to exploit its best qualities. A stick of pastel sharpened and used end-on will produce a strong, narrow line.

Break a stick in half, use it on its side and a wide grainy stroke covers the paper.

You can obtain a range of effects between these two extremes by varying the *size* of the piece used and the *pressure* with which it is applied to the paper.

Once the pastel is on the paper, its character can be totally changed by rubbing. This technique is controversial, but if rubbing achieves the desired effect, it

Hair

I find these colours useful for most hair:

1 black
2 blue grey 6
3 Prussian blue 1
4 Vandyke brown 8
5 Vandyke brown 6
6 Naples yellow 2
7 sanguine conté
8 lemon yellow 2

The four examples of hair shown here are a base for an infinite variety of colourings. I work from the darkest to the lightest tone, rubbing occasionally to create in-between tones and the more subtle colours.

I painted the blonde hair on the lower right by blocking in the whole area with Vandyke brown 6, taking care not to use too much pressure. Next, I applied some sanguine conté to the parts of the hair that were lighter in tone and then did the same exercise with Naples yellow 2. Finally, I applied the highlights with lemon yellow 2. Note that highlights can be small areas of the brightest colour.

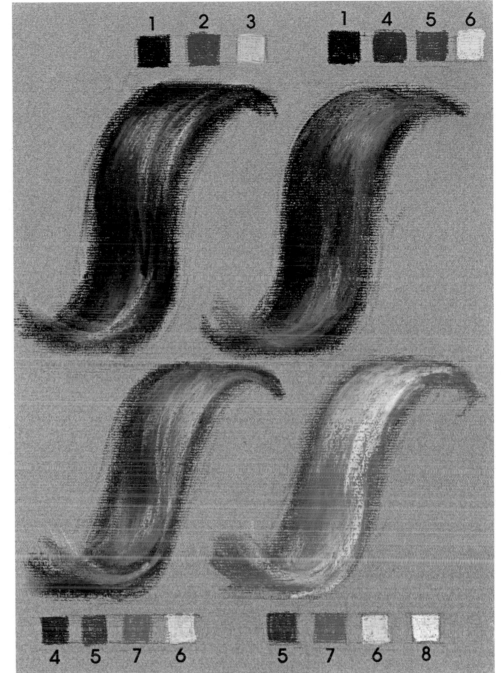

seems justifiable. Superb works in pastel have been produced both with and without rubbing.

I do a lot of rubbing in the early stages of a pastel to create the right colour, tone and balance. In the final stages of the work, I apply the pastel in firm, decisive strokes on top of underworking, to give an effect of spontaneity and vigour. I use the side of my little finger to change the shape, texture or weight of a pastel mark. I find it is more sensitive than any paper stump that is available for this purpose, though somewhat messier. If you use the rubbing technique, remove excess pastel dust by blowing on the paper while you are working. I work with my board upright and find it disconcerting when dark pastel dust descends from the upper to the lower part of the work. Vigorous and regular blowing is essential when working in pastel.

Painting children

Most of my commissioned works are portraits of children; they are very satisfying to complete. The most difficult part is to try to persuade a child between two and five years of age to sit still for more than a few moments. If you talk to a little child, he or she will look straight at you, giving a full-face pose. Ask someone to talk to the child from the side and you have a profile. Little children are most still when being read to, watching television or just fast asleep. You will have to take your chance when it comes unless you are an extremely fast worker.

Emma: demonstration

I find profiles are the easiest portraits to complete. There is no problem such as a full or three-quarter view that requires a foreshortened nose, or a mouth and lips needing a fulness that can only be described by tone. But profiles do have problems of their own, especially when drawing the eye. Unless you study the shapes carefully, an interpretation can look wrong and disappoint you.

To give this demonstration interest, I asked Emma to tilt her head forward so that the painting became more than a mere silhouette. An alternative would have been to turn the body towards me while keeping the head in profile. (See also 'Detail', page 92.)

Stage 1 (above)

As always with children, I had to work fairly fast, so that I had made a good start when Emma's concentration waned. I sketched the profile with black conté, making sure that the head, neck and shoulders were outlined correctly. For the sake of this demonstration, I centred the head in the picture. Usually I allow more space for the face to look into than at the back of the head.

Stage 2 (page 91)

I began to build up tone, using madder brown 8 for the shadows and white for the hair, ribbon and clothes. I made all these marks with the side of the pastel stick to avoid a too specific effect at this stage. Next, I added a little colour: poppy red 6 in the ear and eye shadow, green grey 4 into the background and a little cobalt blue O in front of the face. I rubbed the flesh tones, made with madder brown O, on the cheek and nose. I also diffused the density of the pastel on the eye, ear and dress with my little finger.

Stage 1

Stage 3

In stage 2, I established the hair tone and in this stage I gave the hair its colour values with Vandyke brown 8, black and lemon yellow 4. I used black sparingly for the darkest areas at the back of the hair and at the front of the fringe. I rubbed in lemon yellow 4 to give the right amount of highlight.

I built up the flesh tones by blending more madder brown O, and poppy red 6, using rubbing rather than too much pastel to create the right density. A little blue grey 4 introduced to the nose and mouth area gave recession and shadow when rubbed. I defined the shape of the eye with black conté and did the same to the ear, chin and jaw with Vandyke brown 8.

I found the tonal values at this stage of the work a little out-of-balance. The portrait appeared 'top-heavy' because of the dark mass of hair and the lack of weight in the dress and shoulder. I consider my work as a series of corrections that diminish to the point where I am satisfied that each problem has been confronted, studied and solved.

Stage 4

My concern at this stage was to refine the portrait. I worked some green grey 6 into the hair to reinforce the shadows and then overpainted with Naples yellow 2 to suggest highlights and direction in the hair. I made these marks with the side of the pastel and used more pressure in the middle of the stroke than at the ends.

I put a touch of cobalt blue O into the cheekbone and on the background before the face to emphasize the profile more. To create the illusion of more space

Stage 2

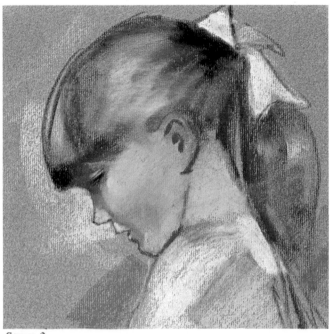

Stage 3

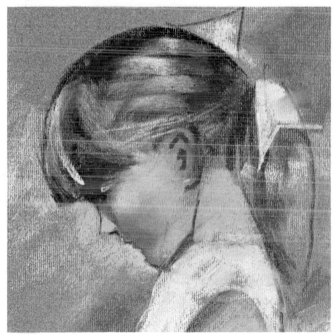

Stage 4

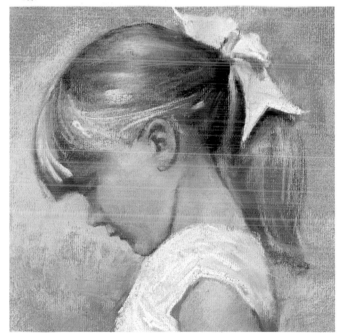

Stage 5 – the finished painting

before Emma than behind her, I added grass green 1 to the lower left-hand corner and green grey 4 to the top right.

Stage 5 – the finished painting

Although the portrait was nearly finished, much tonal adjustment was still needed. I used a 1 in. (25 mm) piece of sanguine conté on its side to add warmth to the hair, then skimmed as lightly as possible over the top with silver white to give a glazed effect.

Moving down to the face, I applied poppy red 6 lightly over the eye area, cheek and chin to give a less harsh effect. I 'broke' the hard line of the nose and mouth by dragging the pastel on the face and that on the background into one another. Almost the entire difference between the flesh tones in stages 4 and 5 was produced by rubbing in. I diffused one tone or colour into another with the side of my little finger; no more colour was added to the paper: all I did was to redistribute colour that was already there. I put a mass of cobalt blue O in front of the face to sharpen the

91

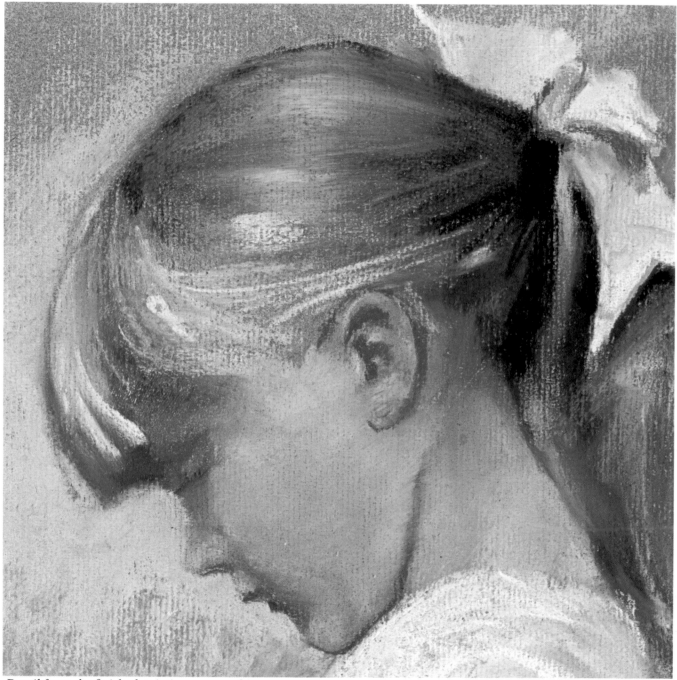

Detail from the finished painting on page 91.

profile without using any strong colour or harsh line.

For the dress I worked Rembrandt pastel over the original silver white mass of the dress and ribbon. I dragged some of the flesh tones into the cloth on the back of the shoulder and then put in the shadows on the sleeve and ribbon with blue grey 4.

Detail (above)

There are no definite hard edges in or around the eye. The strong profile shape hardly has a line in it; it is composed mainly of 'dots' of colour.

Points to remember

Four drawing techniques specific to pastel give more style, rhythm and success to every work. They are:
Pressure of stroke – the length of pastel stick and the weight with which you apply it determine the character of the line produced.
Rubbing – how you shape a pastel mark once it is on the paper makes a vast difference to its visual effect.
Lost and found – it is far more effective to insinuate an edge (such as the profile of a face or a hairline) than to draw it as one hard, mechanical line. Read the caption to stage 4 of the painting on pages 96–7.
Overstatement – it is sometimes necessary to overstate a colour to produce the right effect. Knowing when to do this comes with experience.

Facial expressions

A common criticism of a finished portrait is the lack of a broad smile, for a face in repose has a serious expression. A camera can record the broadest smile in a fraction of a second, but a sitter cannot be expected to hold a smile for longer than a few minutes. To capture any momentary expression, learn to study a face and remember its details once the individual has gone.

You cannot render a natural expression by drawing a smile only on the mouth. Study your own smile in a mirror and then watch the changes in musculature as you let the smile relax. When you smile, the eyes narrow and little pouches appear beneath them. The distance from below the nose to the top lip diminishes, the mouth widens and the cheeks become more rounded, which in turn widens the nostrils. The whole structure of the face alters.

Pastel portraits from photographs

There is nothing wrong with painting from photographs, though purists insist that all drawing and painting must be done from life. If you use a photograph as a source for a portrait, strive for a result with a 'painterly' quality, rather than slavishly copy the print. The aim of working in pastel is to interpret a subject and say: 'This is how *I* see it'.

For some subjects photographs are the only sources of reference; they are invaluable for wild life, foreign places and so on.

Although I do most of my work from life, I have worked from old, poor-quality or black-and-white photographs. I find it a challenge to produce a picture that looks like a painting.

Keep a scrap-book as a source of reference. I collect pictures of people, places and figures that have caught my attention. I have referred back to almost every one of them at some time over the years.

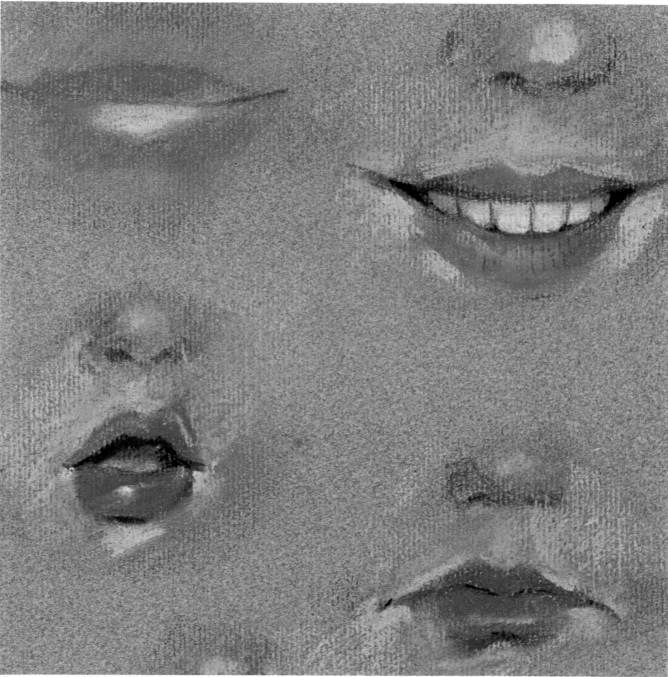

Painting mouths

Painting mouths

The mouth at the top left on this page illustrates the basic colours used on the other three. To draw the mouth on the top right, begin by indicating the top lip and edge of lips with bistre conté, as is just visible on the mouth at the top left of the page. Use sanguine conté over the areas of lips and flesh and then overpaint with madder brown O. Rub these colours together to produce a subtle blend of tones. Now indicate the lips with poppy red 6 and put in the teeth with silver white. Place dark areas of shadow behind the teeth with black conté and use a little blue grey 4 for the lighter shadows on the teeth on the left. Add flesh highlights with madder brown O and put in tiny grooves on the lips with conté sharpened to a fine point to give texture.

The two other mouths above are variations on the same theme. Use the same procedure.

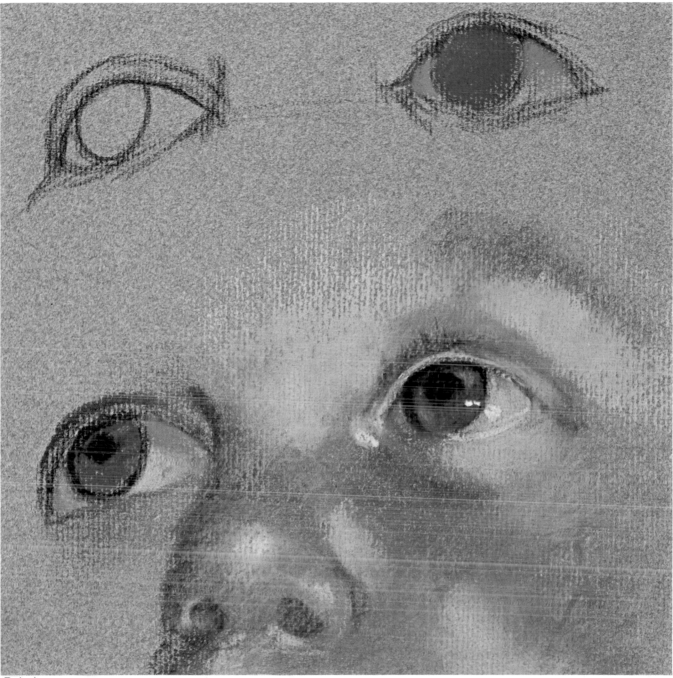

Painting eyes

Painting eyes

For the sake of demonstration, the four eyes above are shown in various stages of development.

Begin by drawing the eye on the top left with bistre conté. Then add blue grey 4 and blue grey 6 as shown at the top right. On the lower left, outline the iris and pupil in black conté and use indigo 1 and blue grey 4 for the white of the eyes (which I never paint plain white, lest it appear too stark). If you study a baby's eyes, you will notice that the eyes are quite blue and nowhere near white.

To complete the eye, rub the indigo 1 over the edge of the blue grey 4 so that it is the dominant colour. Give form to the iris, darken it with blue grey 6, and add tiny touches of light with indigo 1. Put in the point of reflected light with Rembrandt white, and mark a dash of poppy red 6 in the corner of the eye.

The tonal values for the skin surrounding the eye are equal in strength to, or lighter than, the white of the eye, except where there are dark shadowy areas.

Boy fishing: demonstration

One weekend I visited an old mill not far from my home. There was a wide stretch of water beside it and some boys were fishing there. It had rained recently, the river was quite swollen and the boys seemed to be concentrating more than they usually do when in a group. Each was watching the float and ready to strike at the slightest twitch or tug of a fish. Luckily, I had my pencils with me so I made some action studies of these lads.

Stage 1 (Page 97)

I studied the sketches I had made and decided to choose one with a high eye-level because I felt that a horizon of stream or bank did not help the composition.

I made a tentative light drawing in black conté, taking great care with the proportions. When they were reasonably accurate, I used compressed charcoal boldly, to strengthen some of the most important lines.

Then I studied the original sketches made at the mill and began to work in the darkest tonal areas with a 1 in (25 mm) long piece of madder brown 8 used on its side. I think only in terms of tone at this stage of a drawing, as I consider the balance of darks and lights to be most important for a successful study.

Stage 2

As the sun was bright and the water lively, I decided to be vigorous throughout the preliminary stages of this sketch, knowing I could always mute the more strident areas later by lightly dusting them with a flat 2 in (50 mm) varnish-brush that I use just for this purpose.

I began to give mass to the figure by using a piece of Prussian blue 8 on its side. I used Vandyke brown 6 and viridian 6 on their sides for the hair and rubbed them in a little with my finger to give depth. The viridian 6 added at this stage is used purely as an under-colour; although it hardly shows in the finished drawing, its presence is detectable. The cool colours on the head gave a basis for recession so that the warm colours to be added to the highlights later would stand out. I laid in the neck, arms and legs with a flesh tone made from madder brown O and poppy red 6, making no attempt at final colour but concentrating on tonal weight and overall balance in the work.

I added a little silver white on its side as a high tone and then used its sharp edge to denote *direction* of form rather than form itself.

Stage 3

Satisfied that the basic lines and tones were correct, I began to work up the form and colour. I added darker tones to the hair and a light tone to the crown to give form. I introduced poppy red 6 to the ear area, then blocked in the shirt tones with silver white and cobalt blue 2, using the latter colour for the shorts as well. As the boy was dressed in cool colours and only the flesh tints were warm, the choice of background was critical. I laid in cobalt blue 2, silver white and sap green 3, but these appeared too strong so I toned them down in the final painting. I used cobalt blue 2 and silver white quite heavily around the head so that the profile became more pronounced.

Stage 4 – the finished painting

To produce the effect of swirling water, I overpainted the background with silver white, madder brown O, Naples yellow 2, viridian 3 and lemon yellow 4 to make up the water. Note that these are not 'water' colours but give a powerful impression. The shadow on the lower right of the painting echoed the dark area on the shirt and gave depth to the water. I was still uncon-

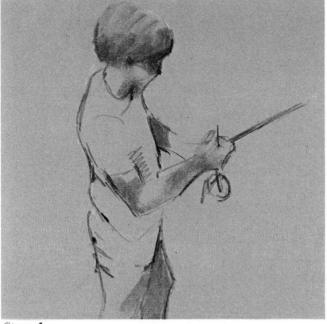

Stage 1

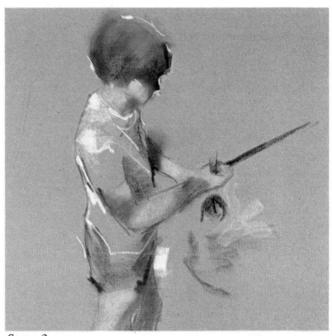

Stage 2

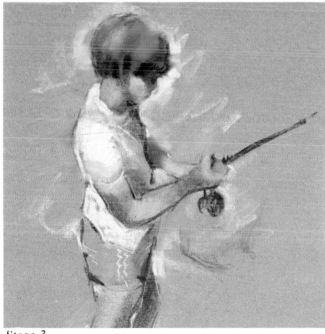

Stage 3

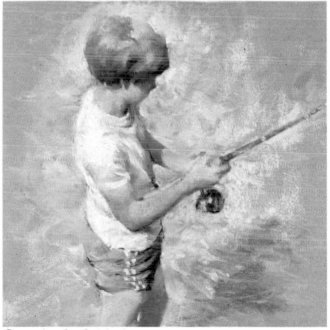

Stage 4 – the finished painting

vinced by the background, so I added a few curved strokes of Prussian blue 1 and blue grey 14, which gave more substance to the water.

I began the final work on the figure by overworking the head highlights with the sides of silver white and blue grey 4. When adding highlights, I used varying pressure on each stroke so that a whiter highlight was produced by applying a slightly harder pressure at the end of the movement. The edge of the hair at the top of the head is not a continuous line but is 'lost-and-

found': the tonal change is only *insinuated* by the preceding and following white line. This is also noticeable on the left forearm on page 98.

I rubbed poppy red 6 on the cheek to create shadow, and modified the dark area dividing the head and neck to give continuous tone and tilt the head further away.

I reduced the harsh drawing in the arm by rubbing and gentle overwork to describe the soft flesh. I used poppy red 6 and blue grey 4 for the the mauve shadows on the right forearm and left leg. (*See overleaf.*)

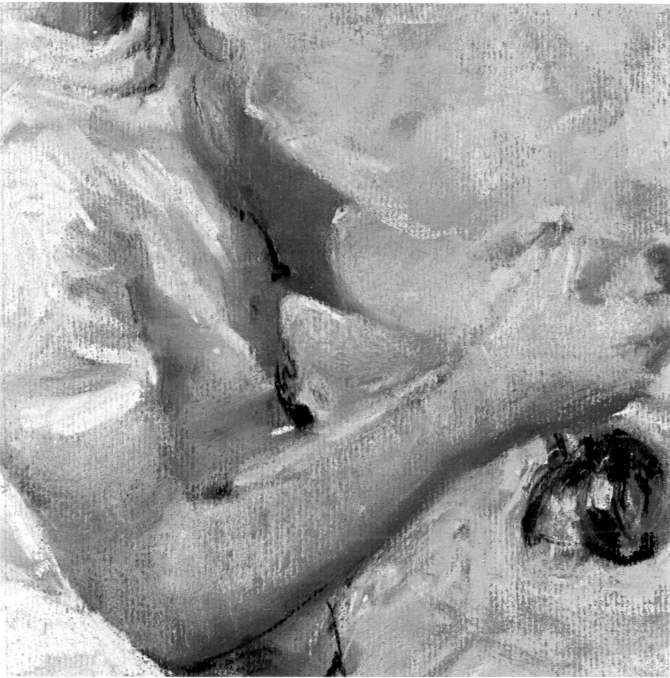

Detail from the finished painting on page 97.

Detail

Outlines were accentuated in some areas by differences in tonal value. This is apparent on the left arm: the 'lost-and-found' technique described in stage 4. The fishing-reel was painted scrappily but looked realistic in the finished painting. There were no specific details in the hands, just colour changes and varying tones.

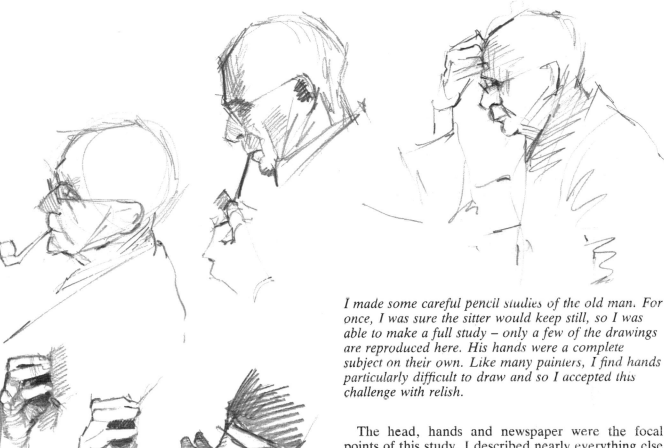

I made some careful pencil studies of the old man. For once, I was sure the sitter would keep still, so I was able to make a full study – only a few of the drawings are reproduced here. His hands were a complete subject on their own. Like many painters, I find hands particularly difficult to draw and so I accepted this challenge with relish.

The head, hands and newspaper were the focal points of this study. I described nearly everything else with Vandyke brown 6, making sweeping strokes with the side of the pastel. Next, I introduced white into the hair, moustache, collar and newspaper as the highlights of the picture. I laid in the preliminary flesh tone with madder brown 0, and used some cadmium yellow 1 on only three areas of the background.

Stage 2

I stopped to study my painting as I was unhappy with the shapes. I decided to change the position of the left hand. I dusted it off then reworked it with madder brown 0 and poppy red 6; this greatly improved the overall composition and made the sweep of the left arm less dramatic.

I went over the figure and restated the darkest areas with compressed charcoal, adding some to the background as well. I find that compressed charcoal is best as it is quite black and does not crumble. I gave some form to the newspaper with silver white, cobalt blue 2 and compressed charcoal: I made no attempt at detail but simply laid in areas of different tonal weight to give an *impression* of printed type and pictures. I built up the background with generous strokes of madder brown 0, cobalt blue 2 and silver white. I worked more colour into the head with a small piece of madder brown 0 to strengthen the highlights. I used poppy red 6 to give prominence to the ear and cheek.

To keep the basic forms clearly defined, I redrew them with black conté, taking care not to let this black line become too dominant.

The library reading room: demonstration

It is hard to find a place where people are still and quiet. It had never occurred to me before that a library might be a place ideally suited to my needs as a portraitist. The old gentleman here had a fine head and features, but I was more struck by his interesting position. He had no moustache, and I decided to add one to soften his rather sharp features. He was completely oblivious of all around him; even the no-smoking sign went unnoticed.

Stage 1 (page 100)

Of the several sketches I made, I found this one most appealing. The way he supported his head with his hand allowed me to make a space at the centre of the picture into which he could look. I used the sharp end of a piece of black conté to set out the drawing and establish the proportions. I found that the composition was more difficult than it seemed, as the arms, back and newspaper formed long bold shapes that had to be balanced carefully.

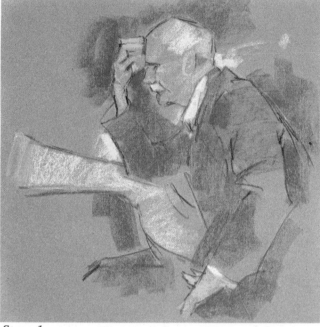

Stage 1

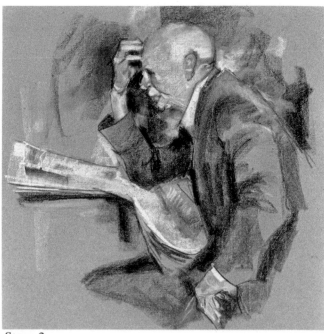

Stage 2

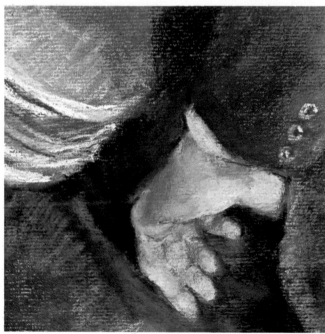

Detail 1

Detail 2

Detail 1

Even though this hand is not particularly well-drawn, it gives a good impression. I used a touch of cobalt blue 2 on the fingertips and wrist.

Detail 2

I overstated the colours of the highlights out-of-context, but these parts are not too prominent when viewed at a distance. Study this detail with a magnifying glass and note the extremes of colour used.

100

Stage 3 – the finished painting (opposite)

Now that the overall balance was right, I worked on the flesh tones, building up their form with madder brown 0 on the face and hands. I picked out the highlights in the jaw and temples with cobalt blue 0 and used lemon yellow 2 to denote the sharp highlights across the nose and cheek. These two colours were not present on the face in reality, but if they are used in a pastel in this way, the viewer's eye mixes them to create just the right colour and tone of flesh.

Stage 3 – the finished painting.

Now that the flesh colours were substantial, everything else looked incomplete, so I started on the newspaper by rubbing it softly until it was light grey all over. Then I added some dark grey areas to simulate pictures, and shadow under the arm. Lastly, I put in horizontal white lines, using the pastel on its edge. This produced exactly the effect I was hoping for.

I applied Vandyke brown 6 to the suit and rubbed it to give an overall covering. I strengthened the shadows and folds with compressed charcoal and Vandyke brown 8 and I used a little caerulean 2 on the sleeve just below the highlights. The background still needed much work; I added grey green 6 on the right and Vandyke brown 6, olive green 4 and lizard green 8 in the darker background. I arranged these colours around the figure to give maximum contrast: that is, very dark next to very light. Madder brown 0 used with discretion echoed the flesh tones. The direction of the stroke is important as it can echo or contrast the shape of the figure.

Nude: demonstration

Painting nudes is a great challenge as mistakes or a phlegmatic approach show very clearly. I find a bold attitude is essential but this does not necessarily mean using bold lines or colours. This demonstration is a strong drawing, but has sensitivity, which is what I aim for.

I find that the 'perfect' figure is not the most inspiring to draw or paint as there are fewer difficulties or new problems to be solved. The subtle tones of muscular variation in the back of this young girl make an interesting exercise in painting flesh.

Stage 1 (page 103)

I used black conté to outline the figure and establish the position and proportions. Conté is the ideal medium for this preliminary work as it can be erased at this stage or overpainted with pastel later. Then I strengthened the main structural lines and shadow areas with compressed charcoal. Notice that I have slightly changed the sitting angle from the position in the original drawing.

Stage 2

I began to give the figure solidity by adding the darkest tonal areas in madder brown 8, used on its side. I rubbed these slightly to soften some of the hard edges. To begin with, I exaggerated each tonal value so that the relative tonal values were clearly defined and I was sure that they were correct. It was easy to diminish their strength later.

Stage 3

I used a restricted 'palette' in these early stages so that I concentrated on tones and kept distracting colours to a minimum. I reduced the strength of the darker areas with madder brown O. To make this effective and give variety to the strokes, I broke a stick of pastel to about ¾ in. (18 mm) and used it lightly on its side over the whole figure, applying more pressure where I wanted highlights. Then I merged the tones into each other by rubbing with the side of my little finger.

I added some Vandyke brown 6 for the hair, making no attempt to create anything other than a soft mass of tone.

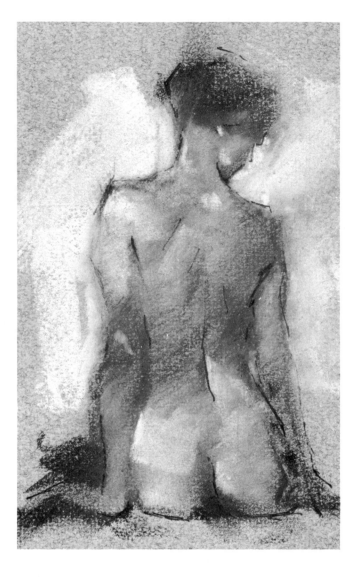

I made this sketch in about 15 minutes at an evening life class. It breaks down into four clear working-methods, as follows. First I made a simple line-drawing in pastel, purely to map out the proportions. Then I blocked the darkest areas of tone and rubbed the edges of these areas to give softer parts. Next I reinforced the form by adding highlights, and finally redefined the original drawing in some parts, using black conté to accentuate just a few edges and give rhythm to the figure.

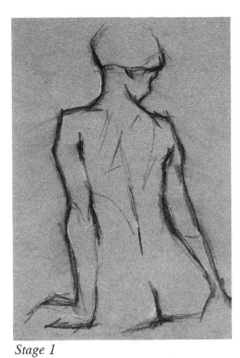

Stage 1

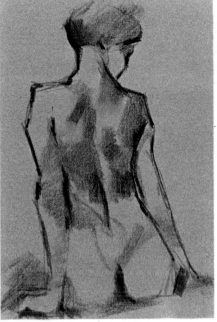

Stage 2

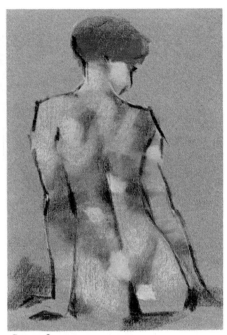

Stage 3

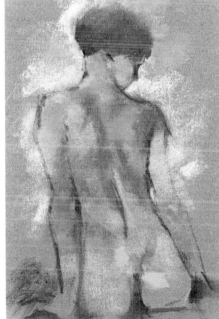

Stage 4

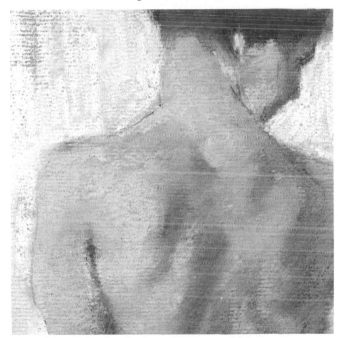

Detail from the finished work on page 104.

Stage 4

I added a white background, letting it run across the edges of the figure and across the upper arms to soften the hard edges. I worked some poppy red 6 into the elbows, cobalt blue 2 and a touch of grass green 4 into the shoulder, neck and waist areas. Although the painting was coming together well, I felt it was still too hard, so I used my 2 in. (50 mm) flat varnish-brush to balance and even-up the tones and soften some of the harder edges.

Detail

Study the reaction of pastel to the tooth of the paper. When rubbed hard, the pastel is pushed into the crevices between each ridge, giving a soft, flat tone. When rubbed lightly, a more grainy texture is apparent and an optical mixing of colours occurs. (*See overleaf.*)

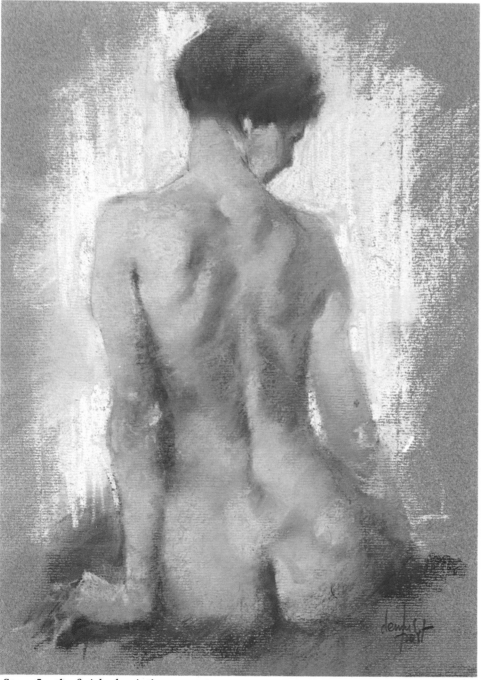

Stage 5 – the finished painting.

Stage 5 – the finished painting

I blocked in the background in a determined manner and took great care with the edges, breaking into some but leaving hard white edges in other places to define a particular curve or angle. I worked into some of the muscle shadows and established a few highlights on the head, elbow and hand. I added Vandyke brown 6 to the lower part of the study to complete tonal and colour balance with the head.

The hair has no definite shape or texture so as not to detract from the figure; in the same way, the face in shadow has been defined by the background. My whole intention with this painting was to show the muscles in repose. I paid special attention to the mid-back area where madder brown 8 shows through a light glazing of madder brown O and poppy red 6. I used light strokes here so that the tooth of the paper gave a grainy texture and an interesting effect.

104

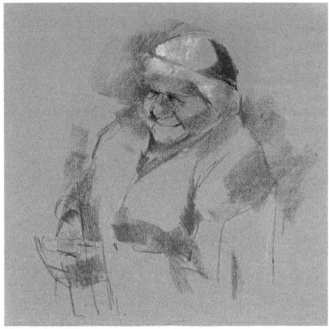

Stage 1

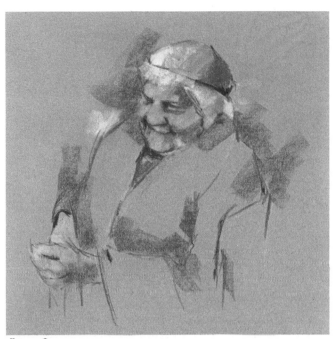

Stage 2

The hairnet: demonstration

Stages 1–2

As usual, I began to lay in the darkest tonal areas, using a 1 in (25 mm) piece of Vandyke brown 6 on its side. I also used it on its edge in some places where it was necessary to strengthen lines and the beginnings of detail. I then established the hair with silver white which, as the brightest highlight, gave me a guide to tonal balance. The opposite to this was the dark area of shadow at the back of the head.

I used terre verte 5 to establish a mid-tone between the dark and light hair tones. At once this produced the first colour that really extended the work. Then I applied the first madder brown 0 to the face and hands to give focal points to the picture. I varied the weight of each pastel stroke to provide variety and tonal contrast.

Stage 3

Then I introduced much more colour, starting with poppy red 6 in the coat where the direction of each stroke was almost as important as the colour itself. I put in the background with Prussian blue 3, madder brown 8, yellow ochre 2 and blue grey 6. I applied this to contrast with the colour and tone of the coat, face and hair. This new pastel had a marked effect on the face as a focal point and I redefined the main features to give more impact, using poppy red 6 on the cheeks and nose and small dashes of Prussian blue 3 near the eye. Facial highlights were put in with short, heavy

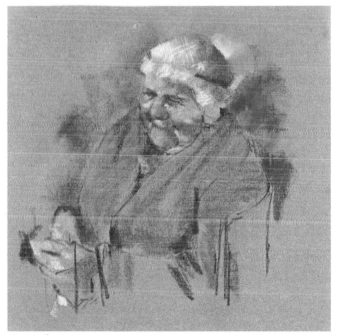

Stage 3

strokes of madder brown 0. I echoed the background colour by including a little Prussian blue in the hands and hair, rubbing it in well on the latter. Then I added more silver white to the hair, and put in some lines with the sharp end of the pastel stick to indicate the hairnet.

Stage 4 – the finished painting (page 106)

I stood back from my work and assessed its progress. It was (and always is) necessary to relate the background to the figure, and the focal point to the distance.

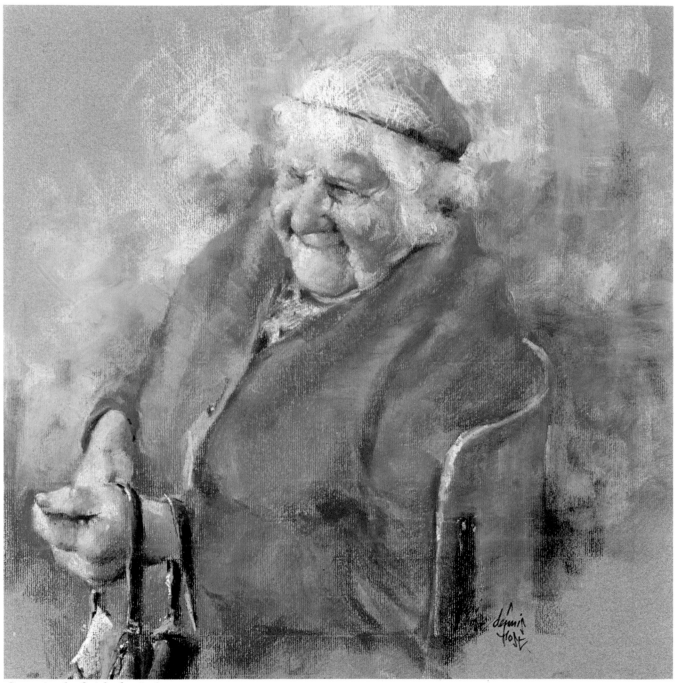

Stage 4 – the finished painting.

As a general rule, if these parts of the painting progress together the results should be harmonious.

I used lizard green 1, Naples yellow 2, grass green 4 and indigo 1 to lighten the area above the head.

The coat needed much more work. I began by using madder brown 8 for the shadows, poppy red 6 for the mid-tones and madder brown 0 for the highlights. This building up of colour, tone and form was a continual process of applying colour and rubbing it in to achieve the right strength.

I went back to the face and gave the contours extra modelling with my little finger, taking great care to build up the smooth chin, nose and forehead, and to exaggerate the depth of the folds in the flesh around the mouth and eyes. Then, to give a robust effect, I put in the final highlights with firm strokes of a short piece of pastel.

A few more sharp lines of silver white to bring out the hairnet and a dark band around the hair completed the head. Finally, I worked on the handbag and chair, giving special attention to their shiny surfaces.

PETS AND ANIMALS

by Sally Michel

Most animal-owners and pet-owners will feel the urge to immortalize their pet, and pastel is an excellent medium for this. It can present the character of soft or glossy fur, feather or down; it is quick – one sweep with a piece of pastel can give a tail, the line of a back; a quick dab, a furry paw; a short twisting stroke, the set of an ear. You cannot keep up with a moving cat, but pastel has a swift responsiveness, and it never runs out of colour half-way through a stroke.

Pastels, made from a mixture of powdered pigment, chalk and gum tragacanth, can be hard or soft according to the proportion of gum used. *Pastel pencils* protect a thin rod of pastel with a wooden casing – useful for lightly drawing the main composition of the picture and for small details too fine for soft pastel. *Conté crayon* comes in black, grey, white, and several red-browns, in square sticks, useful for quick drawings from life, and often used for the basic drawing of the picture. Never use ordinary pencil for this purpose – pastel will not 'take' over it.

Papers. The main requirement is a texture sufficiently rough to remove from the pastel enough of its substance to make a mark, and to hold the coloured powder within the minute depressions and crevices of its surface. (Using pastel on smooth paper is, to put it mildly, unrewarding!) Inexpensive papers can be bought, in a range of colours; Ingres paper has a ribbed texture which shows pleasantly through the pastel; sugar paper, even cheaper, is suitable for rough sketches.

Equipment

What, then, do you need to portray animals in pastel?
1. Pastels in colours suitable for your chosen subject. A box of assorted colours makes a good starting-point. You can add colours as you find out what extra ones you need. Dark, reddish, yellowish and pale browns; yellow ochre; black; some greys; white; flesh pink, a bright red and a yellow (for mouths and beaks) are more or less essential.
2. Conté crayon for basic drawing, and two or three pastel pencils.
3. Cheap paper for rough drawings and sketches.
4. Coloured papers; experiment with different shades for varied effects.
5. A piece of plywood or hardboard, about 16in. × 12in. (40cm × 30cm), with rounded corners, and bulldog clips to hold sheets of paper in place. This is lighter and less cumbersome than an ordinary board.
6. A cheap nylon brush and putty-rubber for correcting mistakes. The brush removes the free powder, the rubber can be moulded to pick up what remains without smearing the surrounding work.
7. Cellophane or tissue paper to protect your finished picture.

Once equipped, spend time familiarizing yourself with the pastels: break off lengths of one inch or less, and experiment with ways of using them: broad strokes with the side of the stick, sharp marks made by moving it forwards instead of sideways: turning and twisting the pastel: pressing firmly or brushing it lightly over the paper. Enjoy yourself. Discover the potentialities of the medium. It will be time well spent.

Quick sketches of a fox, in black conté.

Attitudes towards your model

We are constantly warned of the evils of anthropomorphism. It may be as great an evil to deny that animals have more than purely automatic and instinctive responses, or to see too absolute a difference between the instinctive reactions of animals and the logically, intelligently and emotionally based behaviour of the human animal. It can be argued that human behaviour is also governed by instinct to some extent; certainly our management of human affairs seems less than perfectly logical or intelligent.

Apply these thoughts to the problems of portraying animals: it would seem desirable to steer a course between too detached a view of the sitter and a too subjective one. Observe, measure, and examine, but remember that it is a living being and might be worried or alarmed by close scrutiny; it is as capable as we are of feeling discomfort and boredom, so do not be surprised or annoyed when it walks away when your picture is half-done. You can have a shot at finishing it from memory, or save it until (and if) the model returns. The important thing is to *enjoy* what you do; if the result falls short, console yourself with the knowledge that every attempt teaches you something, and the next picture may be your best ever.

Short-haired cat: demonstration

Now that you are ready to embark on a picture, avoid setting yourself too hard a task. A sleeping cat, in its own home, who knows you, is a good subject to start with.

I walk round my model and make sketches of its general shape and position, in pencil or conté on cheap paper, from different viewpoints, and choose one of these to work further. I then select a paper; in the case of the marmalade cat on page 110, a dark brown Ingres paper, which provides ready-made deep shadows in his richly-coloured fur.

I now draw the main lines of my chosen drawing, often very lightly with pastel pencil and in a colour that does not contrast greatly with the paper. This enables me to make changes if necessary when I draw from the model on this foundation – the pastel pencil is easily removed with putty rubber.

With the paper clipped to my board, I study the general shape of the animal, analysing its structure. I try to be aware of the thickness and bulk of each part of the animal, rather than the edges of these shapes. I aim to feel in my mind each form as I draw it, using one colour of conté crayon or pastel. Do not be afraid to measure, using a pencil held at arm's length. Observe the animal's position in relation to your own. Is the body at right angles to your line of vision, or have you a three-quarters view of it? Keep your work simple, study the main shapes; features not in minute detail, but in the right place (ears and tails can be very expressive). A great deal can be left out, but nothing false put in.

When I have defined the form, I start to deal with the colour, again keeping it simplified. Often I apply the basic colour and rub it with a finger-tip to make a smooth all-over tone; then I add details with firm strokes of other carefully chosen colours over this.

Stage 1

Stage 2

Stage 3

Stage 4

Stages 1–2 (above)

I use red-brown conté crayon to draw the snugly curled-up cat – careful drawing of ears and modelling of the head; the knee drawn up near his head, the whole curve of backbone and tail; the dark stripes defined. For the hair inside the ears and the pale markings on the face I use a very pale yellow ochre. Deeper but related colours define the light markings on head and shoulders, and down the length of the body to the end of the tail.

Stage 3

A similar development of the range of colour is added to the dark patches. I use a very warm burnt sienna for these, varied with yellow-browns of the same tonal strength, and darker browns; and a bright orange on the ears, which are so thin as to be translucent. The brighter colour, more thickly applied, on the head helps to establish it as the focal point of the composition.

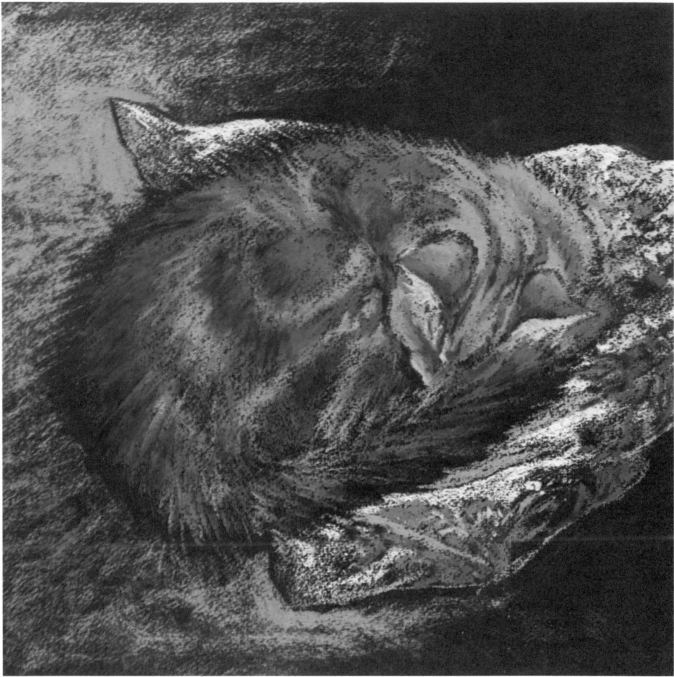

Stage 5 – the finished painting

Stage 4 (page 109)

The pattern on the cushion is kept subservient to the cat. It and the green background provide a pleasing contrast to the bright fur. The green is allowed to fade out round the cushion to provide balance and to avoid the monotony of an area of flat colour.

Stage 5 – the finished painting

The final touches of emphasis and subtle variations of colour have been added; some enrichment of the shadows on the cushion, with varied greys; similarly on the cat's back, mars violet (a purplish brown) gives a richer character to the dark markings. I have to be careful not to overdo this; it is tempting to look for too many subtle variations of colour and turn a telling portrayal into a fussy muddle.

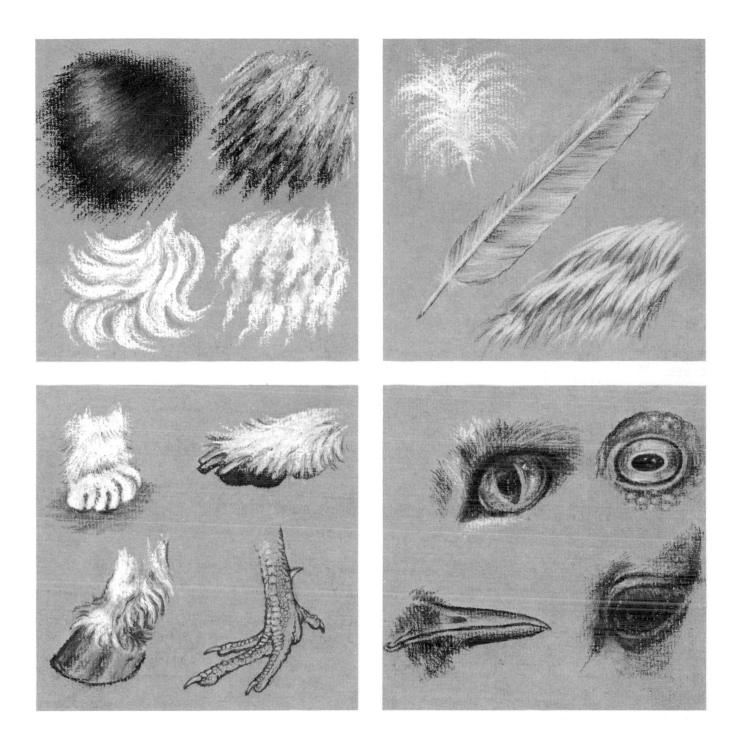

Fur, hair and feathers

Reference has already been made to the different kinds of pastel, and different ways of using them, but it is worth going further into the subject. Soft pastels give up their colour easily and are fragile, which makes them suitable for soft fluffy-edged marks but unsuitable for delineating hard smooth forms, such as beaks, hooves or eyes. For this purpose it is easier to use harder pastels, containing a higher proportion of gum and so stronger, needing greater pressure to remove colour from the stick; the less gum, the more responsive the pastel. Conté crayon and pastel pencil are also helpful with these more defined shapes; pastel pencils can be sharpened and used for very fine work without breaking up in use.

111

Simple animal anatomy

It can be difficult, when one is confronted with a thickly-furred animal, to sort out its anatomy; parts will be clear enough, other parts buried deeply in its pelt. In places the bones are very near the skin, in others covered with a thick layer of muscle, which actually changes shape in movement. Start by reducing the parts of the animal to generalized geometrical solid shapes; think of a body as a cylinder, a head as a wedge (as in horses) or a sphere with a small cylinder in front (as in dogs and cats), legs as posts at each corner, etc.

For a truly detailed animal drawing we have to study the skeletal structure, which can be done at many museums and can be illuminating and instructive, but much can be discovered by handling an animal, if it is a pet (gently and carefully of course), and by watching it move. Watch a smooth lean animal walk and run – a greyhound, racehorse or tiger, for instance. Notice how the shoulder blades move with the front legs, which pivot from the top of the back, not from the chest – particularly well demonstrated by a tiger or cheetah. Such things can often be seen on television, and even better by those fortunate enough to have a video-recorder, who can use it to analyse the changes of posture and to discover the sequences of leg movements in a running animal.

Hair patterns are crucial. These obey definite rules, and cannot be made up – we must either get it right or leave it out. A lot of fine detail does not in itself make a good drawing; if it is not in the right place, the drawing is a failure, however lovingly done. Admiration is often lavished on very bad paintings in which hours have been wasted in putting in thousands of hairs, with enormous care, in the wrong places, when a few minutes spent looking at the animal could have led to a better result. It is better to leave something out than to put it in incorrectly; an undetailed area of colour, with a few whorls and crests indicated where it is important to convey the character of the creature, is more effective than burying telling details in a mass of other minutiae. Trying to show very tiny bits of fur and feather can be self-defeating, as these can appear too coarse and spiky because the scale of the details just is too small to be represented in this way. Pastel is unrivalled for showing softness, smoothness and shine, but less handy for sharply defined details. I am not saying that a lot of fine detail makes for a bad picture, either; simply that a picture is as good as its drawing, and that careful finish, good colour and composition, though they may be praiseworthy in themselves, cannot stand alone without observation and understanding form.

The general shape of birds is admirably consistent as, in most cases, the body of the bird is very much the same shape as an egg. The shapes may vary, some long, some nearly spherical, but so do eggs.

Stage 1

Stage 2

Dog, lying down: demonstration

This dog is a Buhund bitch, Ema, rather like a small elk-hound, from Norway where Buhunds work as cattle-herding dogs. I made many incomplete swift sketches of bits of her in various attitudes. I also used a separate, more detailed, drawing of her head, and other drawings supplied additional information for the paws, the wavy hair on her tail, and her thick neck ruff.

Stages 1–2 (above)

The whole figure is established in this way with black conté crayon. I then concentrate on the golden element of Ema's coat, rubbing the yellow ochre soft pastel into the paper – a pale fawn Ingres paper, carefully chosen to fill in the lightest tone of her fur. Next I enrich the golden colour with deeper tones of golden ochre, lightly rubbed in here and there, but largely left untouched.

Stage 3

Stage 4

Stage 5 – the finished painting

Stages 3–4

Using the side of a piece of extremely dark green, very soft pastel, I define the floor, which both contrasts with the paler underside of the dog, and gives weight at the bottom of the picture – this settles the dog firmly on the floor.

The black overtone is very delicately put on with the side of a soft black pastel very lightly applied so as not to smear on the gold. The black ears, eyes and nose are defined with the tip.

Stage 5 – the finished painting

The white ruff, with grey and very pale cream waves, is picked out in a variety of strokes with both the side and end of the pastel. Details of eyes, and the modelling of muzzle and head generally, are picked out with the same pale colours.

113

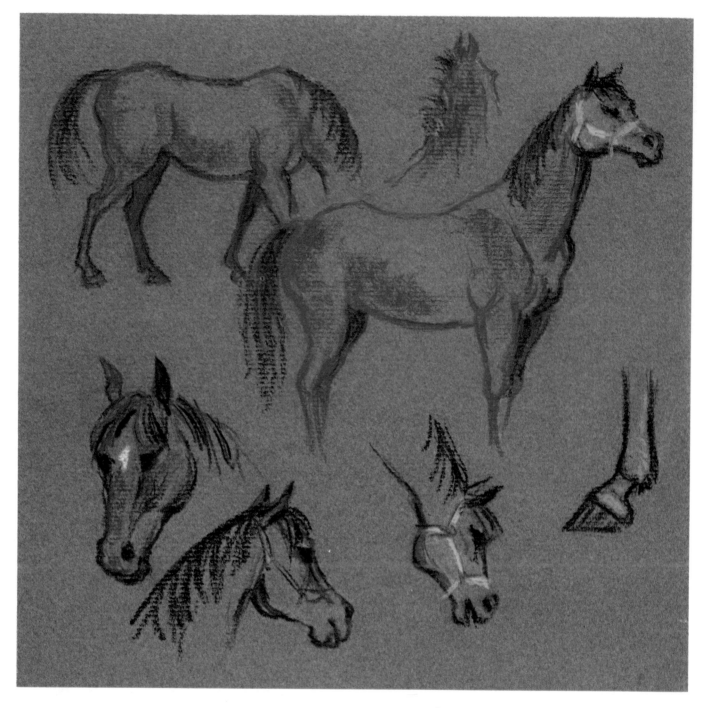

Horses and donkeys

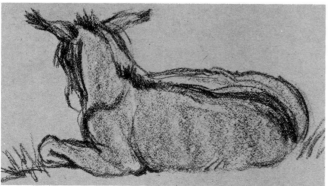

Horses and donkeys are large and complicated animals, in which many people take an expert interest. A painting of a horse is likely to be criticised not just as a portrait of an individual animal, with its own character and imperfections, but as a presentation of the ideal of its breed, so the artist needs to take particular care to observe and measure. Measure often, compare one

Donkey – a sketch in black conté.

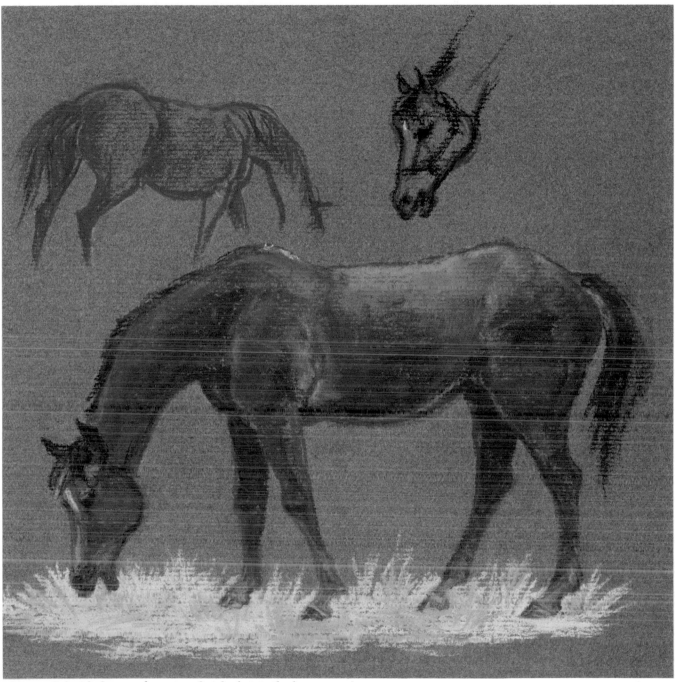

Above: I decided to work up to a finished state the horse grazing

length with another; unless you have an exceptionally accurate eye you will benefit from doing so. Appearances are often deceptive, and if you have got it right, no harm is done by checking. Do not be put off by those who think it is old-fashioned to measure with a pencil held at arm's length. It is a convenient and reasonably accurate way of comparing lengths, and can give one a few surprises.

It is interesting to compare the sizes and proportions of different members of the horse family; the differences are amazing when one considers the close relationship between Shetland ponies, donkeys, riding-school hacks, hunters, thoroughbreds, police and Household Cavalry horses, and the heavy horses which are making a welcome return in country districts. The pictures on these pages show a number of studies of different horses and donkeys, some sketchy, some more finished.

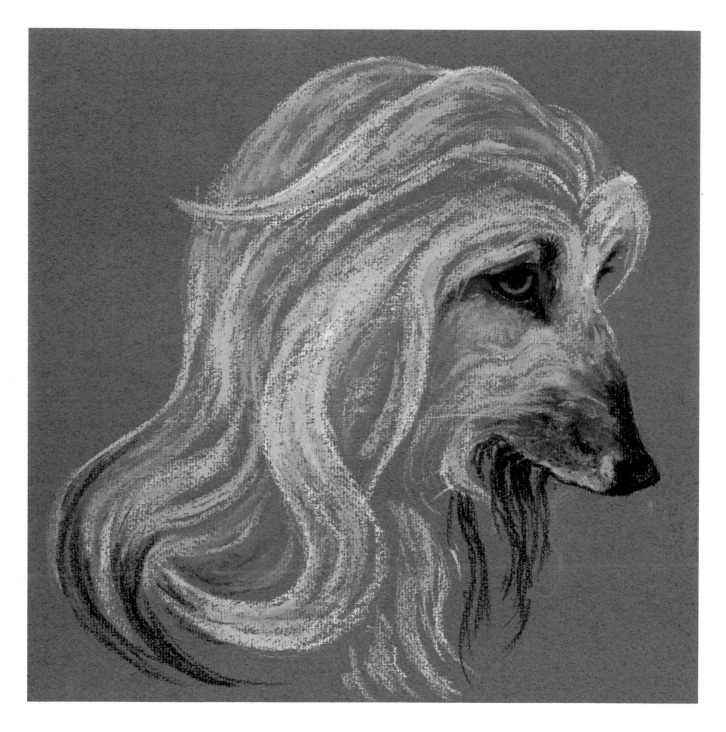

Afghan hound

It is tempting to describe the subject of these drawings, and of the portrait overleaf, as noble and aristocratic – as indeed her antecedents are impeccable and her character as beautiful as her appearance. From previous sketches I draw in her outline in very light ochre – the same colour as her coat. I make sure that the position of her eye is correctly placed in relation to the muzzle and the nose tip. With oranges and light ochres I paint in her lustrous head locks, and add touches of grey to the black muzzle. Lastly, I add her distinctive black beard. Notice how I let the brown paper colour show through in many places.

Animal portraits

My starting-point for a portrait of an animal is the same in essence as for most of my animal pictures; plenty of paper, conté crayon or pencil, and a considerable time spent getting to know the subject. If I am to draw a dog or cat that does not know me well, I have to let it get used to my being in its house before worrying it by staring from close quarters. I prefer to spend the first few minutes chatting with its owner, not looking directly at the animal. This enables it to accept me, the interloper, as just another visitor. I then begin by making sketches from different viewpoints to see what characteristic postures it assumes. Animals are as individual in their mannerisms as are people, and their gait and general bearing are as much manifestations of their personalities as are their faces.

When I have chosen which sketch to use for the portrait, I draw it lightly in pastel pencil, enlarging it if necessary, and taking care where I place it on the paper, leaving spare paper around the drawing in case it needs adjustment. When the sketch is developed into a fully-coloured portrait, it may need to be placed differently within the overall limits of its background.

Before starting work on this finished version, I compare it with the subject, and check measurements, such as the length of the nose compared with the width of the head from ear to ear, the position of the eyes relative to the tip of the nose and the top of the head, and, most importantly, the size of the eyes themselves. Many pictures of animals are seen with eyes unnaturally enlarged, apparently to make them more appealing.

Afghan hound – two of the preliminary sketches of the nose, eyes, face and hair.

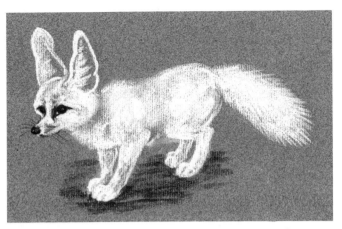

Fennex fox, London Zoo. Black and white pastel on grey paper.

At the zoo

Drawing at the zoo is both a delight and a torment; so many subjects – never enough time! Decide to draw a particular animal, and it will remain invisible, or emerge for a tantalizing trot round its enclosure and back to bed; or it will lie motionless and flat behind the large log that it ought to be posing on. I find it best to plan to study certain animals, but to be ready to change if necessary; if the animal I want is not visible, I go straight on to the next on my list. I concentrate on those animals least often seen in zoos, and on new arrivals.

I cover many sheets of paper with details of eyes, ears, feet; I try to draw the complete animal, but if it is moving a lot, it is difficult to make more than the roughest impression. Even so, these (plus photographs) can supply one with sufficient data for a picture. Ideally, having worked out the whole finished composition from these varied sources, I go back to the zoo and work on it directly from the living animal.

Repeated visits, even resulting in incomplete drawings, greatly build up one's knowledge of animals and ability to draw them. No drawing is ever wasted; even if the result on paper seems negligible, doing it has been of value in itself.

When I visit the zoo, I reduce the amount of equipment I carry to a minimum. A small, light drawing board with sheets of paper clipped to it, and in addition to pastel pencils and conté crayon a small selection of pastels (those suggested as the essential ones in the Introduction) are enough for most purposes. On a pencil drawing a written note can be made of colour, which will prompt your memory. I also find it useful to take a polaroid camera, to record creatures that are not featured on the zoo's own postcards.

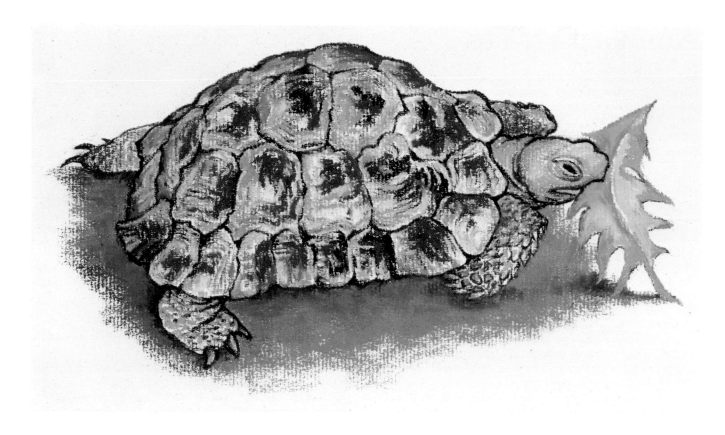

Tortoise. Perhaps one of the easiest of subjects, since it moves so slowly! Study the different textures of horny shell and scaly legs. They offer very interesting patterns and colour variations.

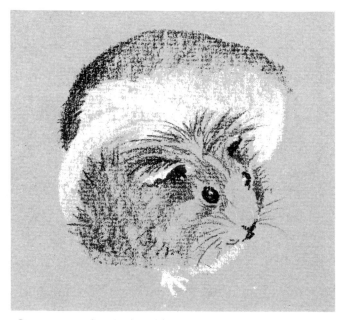

Guinea pig, sketched on blue Ingres paper in black and white pastel.

The zoo in the home

A group of animals intermediate between true pets and zoo specimens are those which we keep in a kind of little domestic zoo; mice, hamsters, guinea pigs, gerbils and rabbits usually live in cages, partly for their protection, partly to prevent them setting up house in the vegetable garden, larder, loft, airing cupboard or other, to us, undesirable parts of the home.

Generally speaking, animals of this sort are not likely to become such devoted members of the family as dogs and cats. They are interesting in themselves, but in a different way; they live in our houses, but are not truly domesticated. Dogs and cats stay with us from choice; dogs in particular clearly show that they consider themselves part of the human pack; cats, despite their popular reputation for aloofness and a preference for places to people, display a clear attachment to their owners and sometimes even to dogs in the household; my own are by no means unusual in accompanying family and dogs on walks in the nearby woods and fields.

While the relationship with hamsters is less personal than that with a dog or cat, we may nevertheless enjoy their individual characters and attractive appearance, take pleasure in observing their behaviour and habits, and the way they pursue, as far as possible, the normal activities of their species in an alien environment.

All our animals ornament our houses and lives as much as the inanimate objects we value; for they permit us to keep in touch with the natural world.

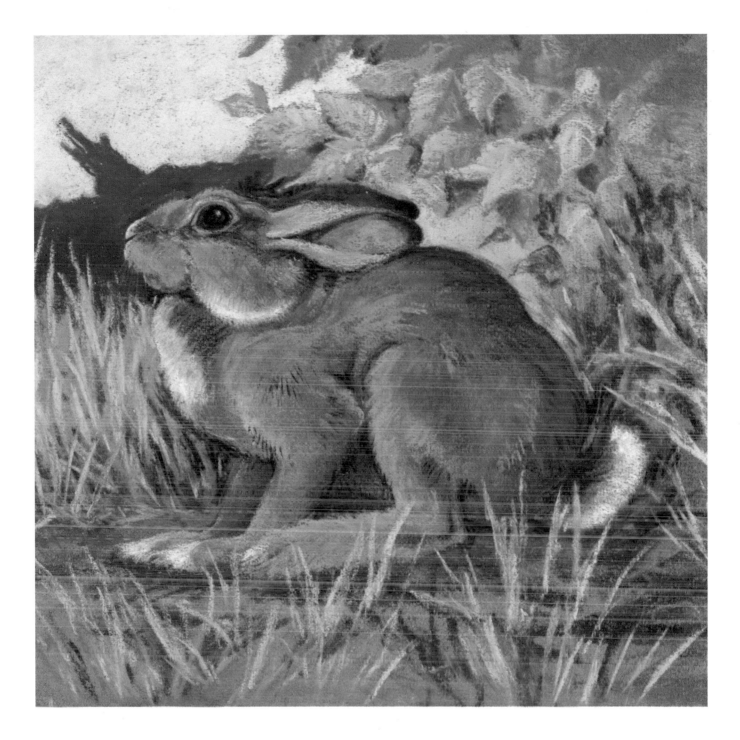

Baby rabbit

I use a brown paper similar to the rabbit's fur but, unlike the Afghan portrait, I blend the pastel of the furry texture with my fingers to obtain the soft effect, touching the form here and there with light browns, white and black. For this portrait I decide to put my subject into a natural setting, adding grasses in sharp strokes of cool greens and the leaves above it in dark, mid and light lines of yellow-green. The distant tree stump in dark brown draws attention to the head.

HARD-EDGE TECHNIQUES

by Christopher Stones

The sharper images in pastel

In some artistic circles it is thought that pastel can only – even *should* only – be used for misty, elusive images with little definition. However, by using a sandpaper support it is possible to achieve the definition of a perfect cut-out edge. Many abstract or super-realist painters shy away from using pastel because of their preconceptions as to what it can do. Yet it is such a powerful, versatile medium.

When I want a perfectly clear straight edge between two colours I fill the sandpaper with the one and rub it in with my fingers, so that it just overlaps the intended border line, filling the surface of the sandpaper completely. Then I lay a see-through plastic ruler or straight edge along the division I want to make. Pressing down hard on it, so that it does not move, I scrub in the second colour up to the ruler, rubbing it in as I go. Then I carefully lift the ruler and have as clear an edge as I could wish. With irregular or curved edges, cut out a piece of drawing paper to the required shape, lay it in place firmly and block in strokes from the cut template onto the sandpaper. If this is smoothed in and the template carefully lifted you will have an absolutely perfect edge. As you get accustomed to this technique, practise it freehand. I make my edges with a very heavy, deliberate freehand stroke using conté or a *medium-soft* pastel, for soft pastel tends to disintegrate with the pressure needed to fill the grain.

A perfect thick line can be ruled in with a conté stick or one of the medium-soft pastels of thin square section, or with a pastel pencil whose wood covering has been cut back to expose a length of the pastel or conté core. It is better if the line is ruled on an area that has been already laid in, as the act of filling in the adjacent shapes may well spoil the clarity of the line. Some people are reticent about using a ruler, but if an edge needs to be perfect for a certain type of painting it is less effective if it is slightly distorted by trying to do it freehand.

Motor car door: Hard-edge demonstration

Many people use pastel to make lovely soft romantic paintings in the traditional sense; but they may not realise that, through the techniques I have previously described, there are wonderfully powerful – sometimes intensely beautiful – images constantly presented to us in the modern world which can be effectively and dramatically portrayed in pastel.

I am fascinated by the double-image effects from glass windows, and by the bright chrome and polished paintwork on motor cars. On page 122 I show a painting of a car door. My prime interest was in the curved glass which reflected a distorted image of a line of cottages and a telephone kiosk, yet also (to a less marked extent) I could see *through* it the shape of seats within and the windows the other side. With the bodywork of the car I wanted to frame the glass area into a square shape in order to make best pictorial use of the strident interactions of shapes.

I first made a simplified construction of a car from a fairly oblique angle, and then cut this down to my square format, carefully considering the shapes of bodywork enclosed in my square and the way they would frame the window. When I was satisfied with the layout I roughly blocked the design onto the paper and then worked each area up in turn. (See opposite.)

Detail 1 (page 121)

The central area of glass was blocked in simply, just depicting the reflected image of the cottages and telephone kiosk. Once this was solidly and clearly defined (and with the paper fully covered) I started to superimpose the shapes of the seats and the other internal details.

Detail 2

I decided to define the bodywork and details of chrome trim of the car with as sharp a definition as possible. For the chromework I had to put in the bands of light and dark so that some edges between them melted from one to the other defining the appropriate contours. The edges needed to be as sharp as I could make them. To

Detail 1

Detail 2

Detail 3

Detail 4

obtain these I fitted the surface with pastel of the adjacent colour. Then, using a template of paper and a plastic ruler laid over in place, I cut the edge in with as heavy pressure as possible without the pastel or stick of conté breaking.

Detail 3

The metallic paint of car bodywork seems to glow rather than actually reflect, and this helped me in this composition because a complex surround would have confused the issue. The paintwork was worked in with my fingers, and then the details of door handle and chrome trim put over the top as already described.

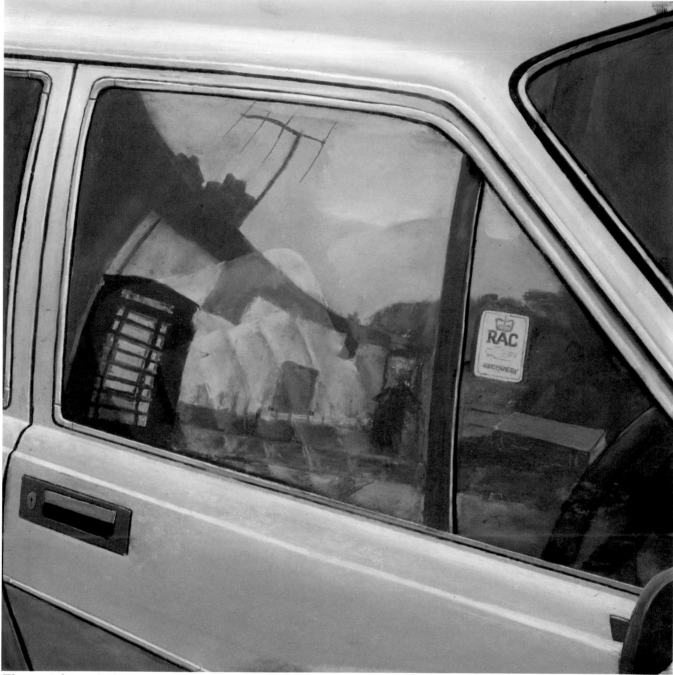

The complete painting

Detail 4 (page 121)

Many people will leave out such details as stickers in a car window, but I find them interesting. Printed or hand-written letters or words in a painting do attract the attention forcibly however, perhaps because of our conditioning to the written word, so use them with care. Very often painters choose to use blind lettering, which gives the impression of lettering without allowing it to be legible.

The modern city skyscraper: demonstration

Although I live in the country I have an increasing interest in city buildings as a source for my paintings. I am fascinated by the strength and angularity of buildings in an abstract way, so that they divide up my paper with strident angles. However, this does not mean that I am altering or distorting what I see – everything is exactly as I perceive it – it is the actual selection of the composition and its distribution on the paper that is important to me.

This genre of painting, which borders on photo-realism, is often thought not to be sensible for the pastel medium; which is perhaps why so many progressive painters seem to ignore the existence of pastel. However, its amazing ability to make very sharp images, as well as its ability to be blended and to form a perfect gradation from one colour to another, makes it eminently suited to this type of work. The key to its extended use is the paper. I use a fine grade (00 Grade) of ordinary woodworking sandpaper, which has an ideal surface for holding the pastel. The 'wet and dry' waterproof abrasive papers used in motor bodywork repairs are not suitable because they do not hold the pastel very well, and lose some of the pigment every time the picture is shaken or jarred.

This demonstration is of a new building of steel and mirror glass, which I found most arresting (and was the source for several other paintings). My interest is chiefly in the dominant reflection of another building in one panel of windows, and how it reflects a distorted image of the other. Most of the picture is a reflection of sky. The ground floor is built of chrome-edged plate glass, which seems amazingly dark compared with the mirror surfaces above it.

My first objective is to try to find a satisfactory composition. It involves three main angles of perspective: the glazing bars which converge horizontally to a vanishing point on my left; the mainly reflected image that finds its vanishing point to my right; and the 'uprights' which converge to a third vanishing point in the sky above and outside the picture frame. (See the demonstrations of perspective on pages 68–9.)

I find that a most useful piece of equipment, when tackling this kind of subject, is a length of string, and (if you are working out-of-doors) a meat-skewer. However accurate your assessment of angles it is useful to be able to check it, so that all angles which require the same vanishing point are accurate. Tie one end of the string to the loop of the skewer (a stick will do just as well). Find the steepest angle at the highest point of your painting and also find the angle lowest down in the painting which must meet at the same vanishing point, and stick the skewer in the ground at that point where they meet, your painting being flat on the ground.

Now, by swinging the free end of the string in an arc on your picture, you can check other angles of struts, windows, roofs, etc. so that they follow suit. If you find this difficult to visualise refer back to Figure 4 on page 5. In 69. In the absence of a large enough table I lay the painting on the floor and attach string to a chair-leg, so that the chair-leg becomes my vanishing point!

Planning the layout

Overleaf is the first drawing made of the skyscraper building. I was very struck by the dark building reflected in the right-hand panel of the mirror-glass structure which was sharply contrasted against the lightest part of the reflected sky. I was fascinated by the interplay between the regular grid structure on the left and its distorted reflected counterpart.

I decided that I would not have the ground in the picture at all; the composition would be made up of fine facets of the glass as the dominant structure. The painting is not intended as an illustration of a place – nor is it telling a story. It illustrates my fascination and enjoyment of studying the interaction of shapes in a rectangle.

The critical part of my choice of composition was in the way the shapes of glass came to the edge of the painting. I liked the balance of the triangles in the top left and top right corners, and I felt stimulated by the strident dark shapes at the bottom of the picture. Test the layout of a painting to make a good choice of the distribution of shapes, look at the subject through a viewfinder – or a rectangular hole in a piece of card. This helps to isolate the field of vision, and you can move it around to ascertain the composition and try possible alternatives. Do make sure that your viewfinder is of the same dimensions relative to the paper you are going to use. If the painting is to be square make the hole square; if of the more normal 2 × 3 ratio let the window in your viewer be of the same ratio.

Stage 1 (page 124)

Moving on from the layout I start on the sandpaper by plotting the positions of the main facets or banks of windows in the building, establishing uprights by the way they all point to one vanishing point in the sky. This I do with the help of the length of string, as described above. To find the vanishing point I take the outermost upright on both sides and extend them to the point where they cross in the sky. All the other uprights line up with that point. My reason for finding the vanishing point with the outermost uprights is that, if it were established using two adjacent uprights, even a small error in assessing the angle would make an enormous difference to the position of the vanishing point. Then I start laying on the colours that I need, noticing the way the colours are graded from light to dark.

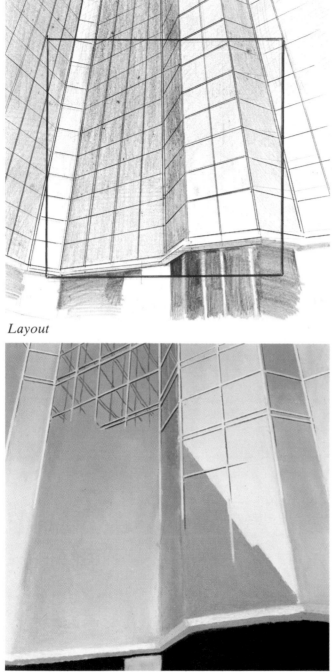

Layout

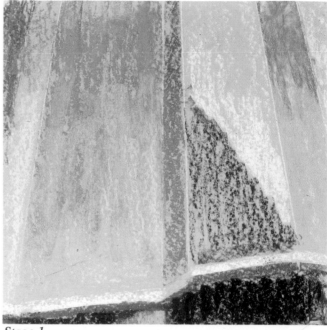

Stage 1

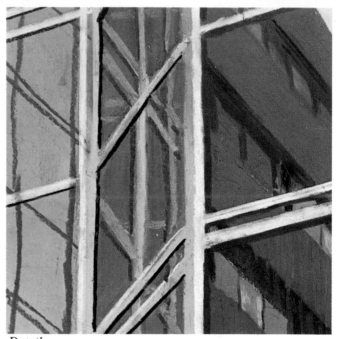

Stage 2

Detail

Stage 2 (above)

For the purposes of this demonstration I have combined two actual stages into one; if you examine the illustration carefully you will understand how I have done this. Firstly, I work over the entire picture surface with the main colours of the glass, building structure and reflection filling the pores of the paper with pigment, working the colours together with the tips of my fingers so that they blend into continuous gradations. Do not rub the sandpaper too vigorously when there is insufficient pastel on the surface – it sounds obvious,

but it is easy to get carried away and forget! This process done, I start on the glazing bars of the windows with the aid of the string. This hard-edge technique can be seen in the upper half of the illustration, and is described more fully below.

Detail (bottom right)

The detail, taken from the finished picture opposite, shows quite clearly the points and techniques I have described in this demonstration. Notice the variety of colours, tones and lines; as well as the linear aspect.

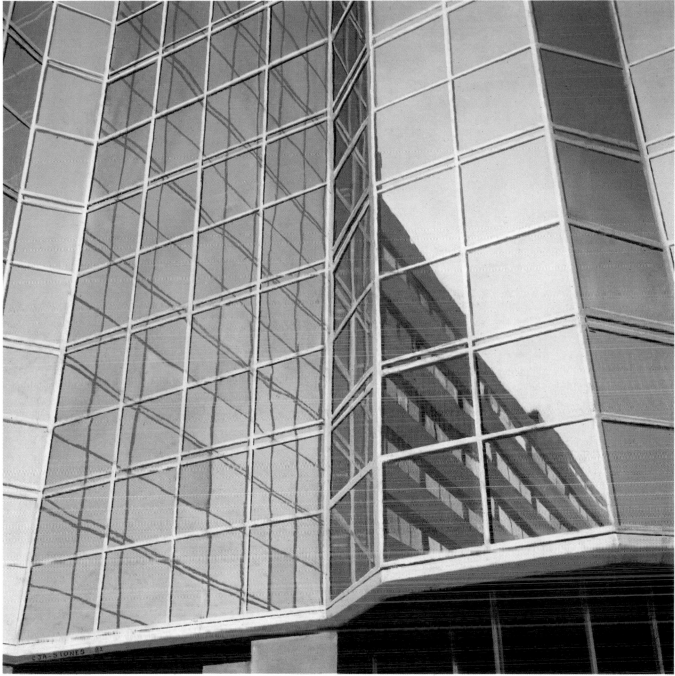

Stage 3 – the finished painting

Stage 3 – the finished painting

I continue to put in the grid of the building structure and its reflected counterpart. I paint the reflected building in freehand, stressing its wavy distortion but, by contrast, the *real* image is delineated with pastel pencils and a see-through plastic ruler or straight edge, taking the utmost care not to smudge the picture surface as I proceed. Remember, you can put dark over light and vice-versa in pastel, especially on this paper, and create a perfectly sharp image.

Storage and framing

by Christopher Stones

Before they are mounted and framed pastel paintings need not cause any particular difficulty. If you are carrying a single painting still attached to your board with pins or clips, just put a covering sheet of tracing or greaseproof paper just larger than the picture over the top and secure it to the board. Polythene or cellophane sheeting is not suitable, as it lifts off some of the colour. Newspaper also takes off some of the particles of pastel, but is quite acceptable if you intend planning to do some more work on the painting later. When you are transporting several paintings these should be interleaved with tracing paper and secured in the same way, so that there can be no sideways movement. Pressure straight down onto the covered surface of a pastel painting does no harm. Sideways movement will smudge it. Longer-term storage of paintings should be treated likewise.

I am not very keen on using fixative sprayed on a finished painting, as a full spray of fixative will change the colours and tones quite noticeably, and a fine or cursory spray will not fully fix the pastel particles. I do use fixative on occasion in the course of painting (see page 11). Some pastellists who like to fix their work hang the painting with clips on a string, like washing on a clothes line, and spray the *back* of the paper, thus holding the particles of pastel down from behind.

There are various schools of thought about framing pastels. Any thin paper will tend to expand and contract with the varying levels of humidity of the atmosphere, and if constricted in mount or frame will cockle with any hint of damp. Either fix the paper to the top edge of the mount only, and let it hang like a curtain, or try to keep all damp out by taping the glass to the frame and the backing board to the frame also, thus excluding all passage of air. A small painting could be actually sandwiched with no air space between two pieces of glass which are taped together at the edges, thus making an excellent seal but the extra weight of glass might be too heavy for larger paintings.

Try to frame a painting in sympathy with its general character or genre. If it is a traditional type of subject, for which you feel a mount would be suitable, I suggest using two thicknesses of mount card in order to raise the glass well away from the picture, the inner mount having its 'window' cut slightly smaller, so that it is just visible inside the main mount. The colours of mount-card used and the width inside the frame are dictated to some extent by fashion, but it is useful if the colours echo the colours in the painting. It is better not to choose a frame or mount which is lighter than the lightest light in the picture or darker than the darkest dark; if you do you will tend to see the frame first.

Many pastel paintings of a contemporary approach can well do with an oil-painting frame. Obviously, it must have a glass; and the painting should be separated from the glass with a card or wood slip, which need not be visible inside the frame. Some paintings need only a narrow metal frame, but these too should allow an air space between the glass and the picture. This air space stops the unfixed painting touching the inside of the glass and leaving traces of the image on it. If this does happen just take the painting out, clean the glass, and reassemble.

Framing

A Stiff backing board
B The painting
C Small window mount
D Larger window mount
E Glass
F Frame

If no mount or border is required and the painting is to be close-framed omit C and D, but insert a thin strip of card or wood in the frame rebate between glass and painting to separate them.

Organisation and care of materials

by Christopher Stones

Until recently there has been no satisfactory working box for pastels on the market. Unless people have made their own they have managed with the display boxes which each manufacturer supplies with sets of pastels. Sticks of pastels are sold in tones graded from dark to light with names that are often unique to each manufacturer apart from the obvious cobalts, cadmiums and ochres, which are common to all, although the system of tones may vary. I find it impossible to work with pastels arrayed like a row of soldiers, each with its allotted niche to which it has to be returned after use. A pastel paintbox needs general compartments for yellows, reds, greys, blues and greens with subdivisions into two or three compartments for light, medium and dark (*see diagram on page 7*). I strip all paper coverings off the pastels before they go into my box, keeping a note of the make, name and number on a colour chart for re-ordering. Each compartment has a thin mattress of plastic foam (removable for cleaning) at the base, and a thicker piece of foam rubber covers the entire box, so that with the lid down the pastels are effectively sandwiched between foam and cannot jump about, sullying each other or being damaged.

The advantage of removing the wrapping paper is that you cannot work according to recipes. There are then no names or numbers on the pastels and you have to judge for yourself the relative warm and cool or light and dark of the colours, which is what the painting is all about. If you are uncertain about using a colour, try out the stick of pastel on a piece of scrap paper of the same colour, before finally committing yourself.

My box also contains a small compartment for a few pastel pencils, and a place for poster-mounting putty or material for sticking up posters and notices where one cannot drive in a pin. Apart from its original use it is ideal for the pastellist. If you keep a piece of this putty in your hands and knead it as you work it will keep your hands clean (and so your face and clothes too!). It stops you passing colour from a stick of pastel that you have just used to the next, and this keeps them clean longer. It also replaces the oils in your hands and nails which, by constant contact with such a powdery substance, can sometimes dry out and crack. You can also use it for lifting out an area of your picture which needs to be repainted, having first flicked out a thick application of pastel with an oil painting hog brush.

Your paper should be pinned, clipped or taped to a drawing board so that it lies flat. If it is not ready-mounted on stiff card or is fairly thin, you will need several sheets beneath it to cushion any imperfections that may come through from the board. For working out-of-doors a light but firm easel is advisable as, when working on your knee, it is difficult to prevent your sleeve getting in the paint. If you do not want to sit on a stool you may still need one on which to rest the pastel box at a reachable height from a standing position.

INDEX